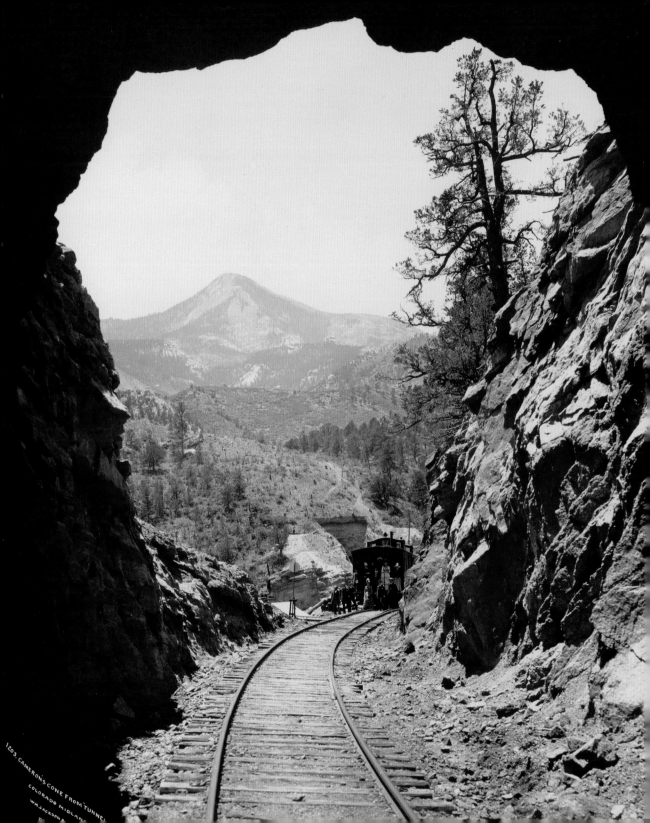

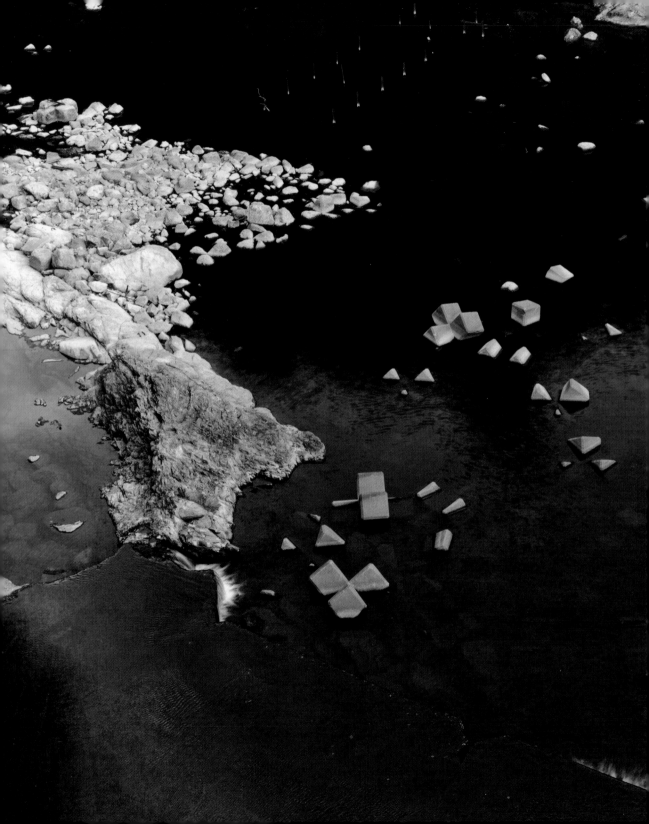

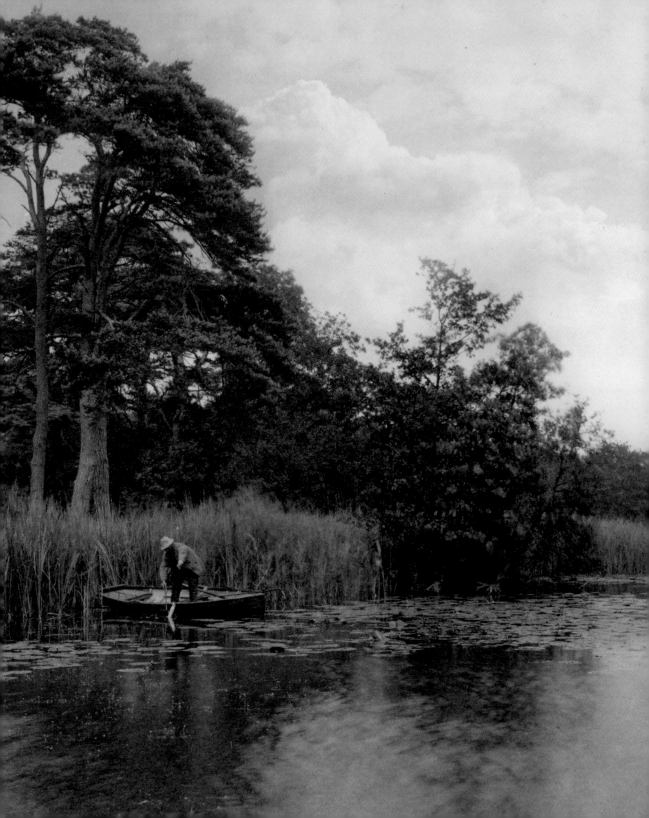

Karen Hellman
Brett Abbott

Land
IN PHOTOGRAPHS

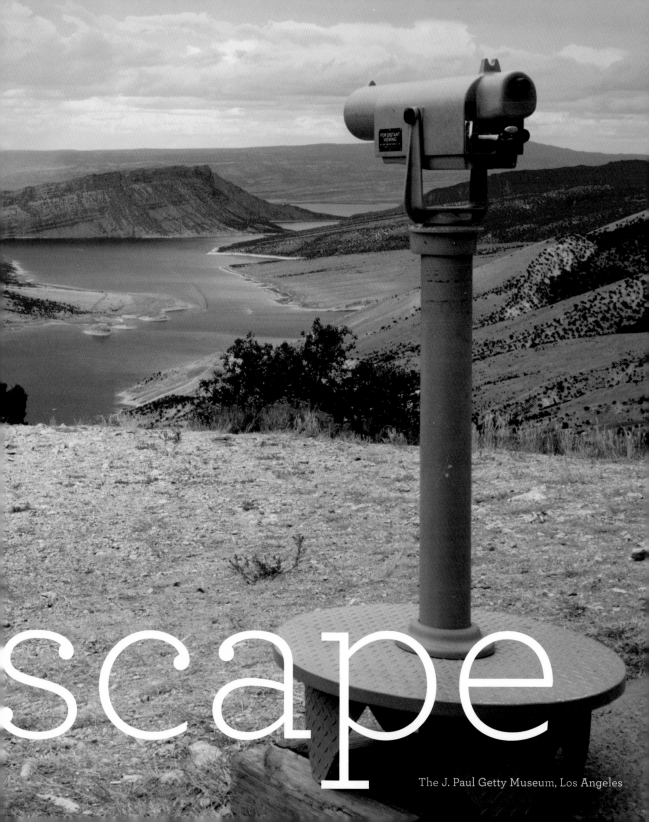

scape

The J. Paul Getty Museum, Los Angeles

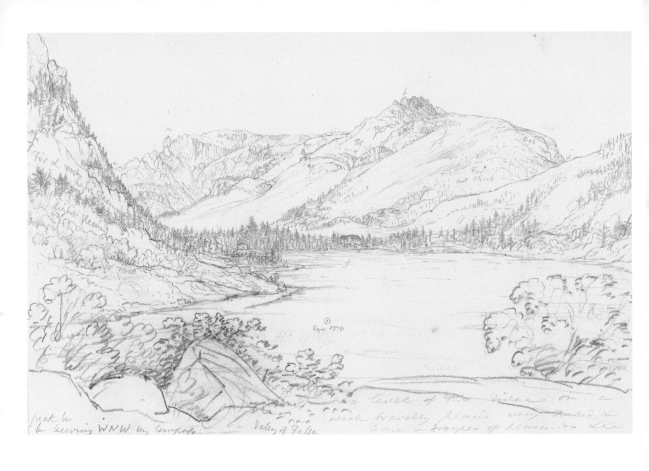

FIGURE 1. Sir John Frederick William Herschel (English, 1792–1871), *Valley of Fassa from Opposite Gras*, 1834. Graphite drawing made with the aid of a camera lucida, 19.8 × 30.7 cm (7¹³⁄₁₆ × 12¹⁄₁₆ in.). Los Angeles, J. Paul Getty Museum, 91.GG.98.32

Nature and the Photograph

Since the beginnings of photography, landscape as a subject has been integral to the conception as well as to the development of the medium. The language used by photography's inventors and early practitioners was often drawn from words used to describe a landscape. In his correspondence with his partner, Louis-Jacques-Mandé Daguerre, in the 1820s, the inventor Joseph-Nicéphore Niépce called his initial photographic experiments *points de vue* (points of view), while William Henry Fox Talbot dubbed photography "the pencil of nature." Copying nature was the initial function of the eighteenth-century camera obscura (literally, "dark room"), from which the photographic camera was derived.[1] The very meaning of the word *photography* is "light drawing."[2]

Histories of photography often begin with an account published by Talbot, who was frustrated by his inability in 1833 to capture the natural beauty of the lake district in Italy using the tracing method of the camera lucida.[3] In the opening pages of his 1844–46 publication, *The Pencil of Nature,* Talbot recounted: "I was amusing myself on the lovely shores of the Lake of Como, in Italy, taking sketches with Wollaston's Camera Lucida, or rather I should say, attempting to take them: but with the smallest possible amount

of success. For when the eye was removed from the prism—in which all looked beautiful—I found that the faithless pencil had only left traces on the paper melancholy to behold."[4] Talbot's "melancholy" was a recurring state for photographers throughout the medium's history as they worked to perfect their processes, and yet it was also the impetus for photography's invention. When he returned to England, Talbot developed the "photogenic drawing" process—the beginnings of paper photography— which he announced to the Royal Society in London at the beginning of 1839.

The fact that the landscape continued to be an alluring and challenging subject for photographers is demonstrated by the hundreds of landscape photographs that are currently housed in the J. Paul Getty Museum's permanent collection, made from just after the inception of the medium to today. The photographs in this book are drawn from this vast resource and illustrate the various ways in which photographers have taken different viewpoints on landscape. The plates are arranged roughly in chronological order to make apparent the range of technical and artistic solutions that were developed as both the medium and the subject evolved.

The birth of photography came on the heels of intellectual shifts within the European scientific communities, away from the idea of nature as passively shaped by unknowable forces to something that, through direct observation and recording, could become completely comprehensible. The eminent British scientist Sir John Frederick William Herschel, who was Talbot's colleague and also instrumental in the invention of photography, serves as an example of this new direction. An astute observer of the natural world, Herschel made hundreds of camera lucida drawings on his travels to breathtaking sites throughout Europe, such as *Valley of the Saltina near Brieg at Entrance of the Simplon* (plate 1). He often marked the placement of the "eye," or prism, on his papers, along with the direction it faced, and made notes on the general outline of the landscape and the weather (fig. 1).[5]

It is not surprising, then, that photography was invented amid this atmosphere. The landscape subject served as both scientific and artistic validation of the medium. The daguerreotype process was praised for its ability to render extremely fine detail, while the calotype, made from a contact-printed paper negative, created a rougher, more high-contrast image of light and shadow. Compare the full-plate daguerreotype *View within Crawford Notch, New Hampshire* (plate 3), by the Boston dentist Samuel A. Bemis, to a salted paper print from a calotype negative, *Colinton Wood* (plate 4), by the Scottish photographers David

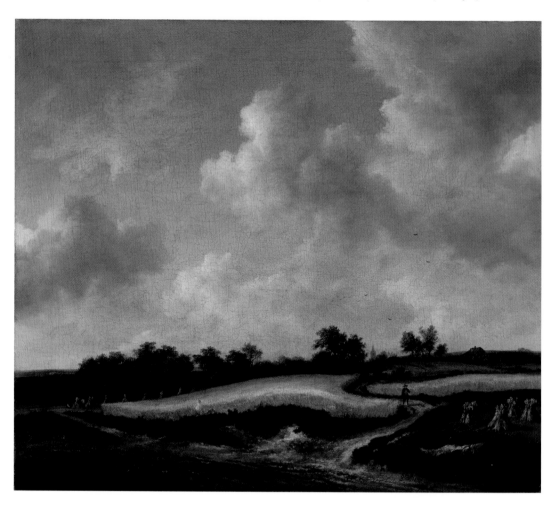

FIGURE 2. Jacob van Ruisdael (Dutch, 1628/29–1682), *Landscape with a Wheatfield,* late 1650s–early 1660s. Oil on canvas, 40 × 45.7 cm (15¾ × 18 in.). Los Angeles, J. Paul Getty Museum, 83.PA.278

Octavius Hill and Robert Adamson. In the daguerreotype, the exposure time was several minutes long. Although this resulted in an overexposed sky, the outline of the forested ridge as well as the detail in the foreground—tree trunks and rocks—is in many places exquisitely distinct. In Hill and Adamson's print, on the other hand, the composition of the bending tree trunk and the edge of the fence is arranged for a more overall harmonious effect, with less attention to detail.

When photographers turned their lenses to the landscape, they were also entering a long-established artistic tradition. As early as 1600, the word *landscape,* borrowed from the Dutch *landschap,* was used to refer to inland scenery. The genre of landscape painting by Dutch painters, exemplified by *Landscape with a Wheatfield* by Jacob van Ruisdael (fig. 2), was established in the seventeenth century. Although composed around the rendering of more naturalistic elements—such as light and shadow, perspective, and atmosphere—van Ruisdael's canvases were primarily imagined views. Elements of the landscape—trees, hills, and clouded sky—took on forceful, even humanlike, personalities. When figures appeared, they seemed to be tiny players in a larger scene in which the main character was a highly dramatized natural world. Until the nineteenth century, landscape was perceived as an inferior genre to portraiture or history paintings. In such works the landscape served simply as a backdrop in front of which the action or story was portrayed.

From Background to Foreground

In photography, the initial use of nature as backdrop was a technical rather than artistic decision. In the early 1840s, it was difficult to capture a figure in a natural setting with the daguerreotype process. Thus, photographers placed the sitter before a painted backdrop in the studio. In *Portrait of Edward Carrington, Jr. ("Uncle Ed")* (fig. 3), the young model had been told to sit still while the backdrop behind him placed him in a rural riverside.

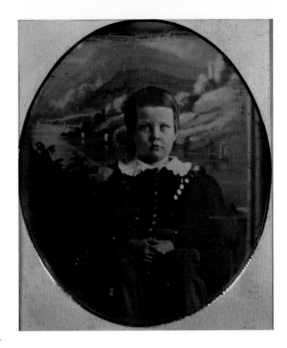

In 1842 (when this portrait was taken), urban centers were expanding with the rise of industrialization, and such a setting became increasingly rare in everyday life. As a result, the natural landscape became more highly valued and frequently represented. While scientists looked to the world around them for evidence of nature's laws, artists developed their own rules for depicting landscapes. The nineteenth-century picturesque motif in drawing and painting, which grew from the eighteenth-century British topographical watercolor tradition, broadly proposed certain standards for an artfully composed, natural scene that had the power to stir an emotional and intellectual response in the viewer. In "The Art of Sketching Landscape," the artist William Gilpin directed readers first to find their "point of view," establish a composition, and then follow a series of steps, from marking the "general shapes" of a scene and delineating the foreground and background to adding light and

FIGURE 3. Jeremiah Gurney (American, 1812–1886), *Portrait of Edward Carrington, Jr. ("Uncle Ed")*, 1842. Daguerreotype, 7.4 × 5.9 cm (2¹⁵⁄₁₆ × 2⁵⁄₁₆ in.). Los Angeles, J. Paul Getty Museum, 94.XT.55

shade as well as color.[6] In the picturesque aesthetic, the image of a landscape was intended to inspire the viewer to reflect as he would on nature itself: on the fleetingness of time, for example, when time had become increasingly regulated, economized, and industrialized. Other artists took a less regulated approach and strove to capture a more immediate experience of nature. Some of the notable artists to take this view were those who formed the Barbizon school (about 1830–70), which was named after the town outside Paris that provided the main settings for the artists' work. For the Barbizon artists, the natural rather than the fantastical world was valued as the entire focus of a work of art.

From Near to Far

Plein air, or outdoor, photographers such as Gustave Le Gray and Charles Marville often shared the same interests and even the same landscapes as their fellow artists (plates 8–9). While they explored the picturesque in the surroundings reachable by train, other photographers in the 1850s boarded ships and made longer journeys to document landscapes most Westerners had never seen. With the improvements in photography, such as collodion-on-glass-plate negatives, the landscapes of ancient civilizations of the Mediterranean could be captured with greater precision and perspective. The results of these excursions provided a viable alternative to what had until then been the exclusive purview of the upper-class intellectual elite—the grand tour. Those who could not afford to travel but were nonetheless fascinated by the "East," or anything beyond familiar Western bourgeois life, could still experience these exotic locations. Photographers such as Francis Frith journeyed to the Middle East and Egypt and published photographs for this audience, including *The Pyramids of Dahshoor, from the East* (plate 13). With his impressive perspective of the vast Egyptian desert, Frith was able to transport his viewers to the ancient pyramids, which rise in well-proportioned succession. Frith also made and sold stereographs, the three-dimensionality of which offered an additional opportunity to re-create the effect of standing before such faraway sites.[7] Stereographs also helped expand the market for exotic landscapes, since they were far more affordable than large album-size prints.

Horizon Lines

When discussing nineteenth-century landscape in the United States, many authors have used the word *sublime* rather than *picturesque*.[8] The subjects chosen by photographers in the New World—mountain ranges, canyons, giant evergreens—were not classical ruins but wild, and somewhat terrifying, natural wonders. These were not rendered by painters before, as was the case for many European landscapes that were later photographed. In many cases, such as Flaming Gorge in Utah and Yosemite Valley in California, photography represented some of the first ever visual records of the location.

Photographers were able to gain access to these sites thanks to government-sponsored surveys that sent lensmen along with scientists, geologists, and artists to document various aspects of the as-yet-unknown land beyond the Mississippi River. The four "great surveys" initiated after the Civil War in the late 1860s and early 1870s were political and industrial ventures as much as they were artistic or scientific ones. The surveyors, who often advanced with the laying of the railroad, explored the western frontier, mapping the land and assessing its natural resources and industrial potential. Two photographs of the railroad, *Niagara Falls, Summer View, Suspension Bridge, and Falls in the Distance* by the Philadelphia photographers Frederick and William Langenheim in the East (plate 15) and *Cameron's Cone from "Tunnel 4," Colorado Midland Railway* by William Henry Jackson in the West (plate 16), accentuate— whether by the stereoscopic illusion of space or the enlarged dimensions of the mammoth plate—both the grandeur of the American landscape and the glorious potential of the country's industrial future as symbolized by the steam engine.

Pictorial Effects

Pictorialism, the vanguard movement in art photography that lasted from about 1891 to 1910, united groups of practitioners internationally to establish their new processes as art. The word *pictorial* in relation to photography was already in use by the 1860s with the publication of Henry Peach Robinson's *Pictorial Effect in Photography*.[9] Robinson's images, constructed within the darkroom using combination printing (employing two or more negatives), adopted the narrative compositions of academic painting. Almost two decades later, Peter Henry Emerson condemned Robinson's "effects" and advocated instead a theory of naturalistic photography.[10] Rather than creating anecdotal scenes in the darkroom, Emerson's photographs, such as *The Haunt of the Pike* (plate 26), were made outdoors and "constructed" through the lens, with keen attention to representing nature as it appears to the human eye.

With the introduction and mass production of the Kodak camera, Pictorialist photographers in the 1890s wanted to set themselves apart from the automatic as well as the technologically enhanced accuracy of detail evident in the amateur photograph. These more selective "art photographers" celebrated the handcrafted print, working with such materials and processes as gum bichromate, platinum, and photogravure. They bought their own equipment, furnished their own darkrooms, selected high-quality materials, and created individual prints on specially produced paper. Their images were intended to evoke an emotional or personally resonant response in the viewer rather than be equal to amateur snapshots. An example of this is *Pastoral, Moonlight* (plate 30), by Edward Steichen. Steichen was a member of the American group called the Photo-Secession, founded by the photographer and Pictorialist Alfred Stieglitz in New York in 1902. Stieglitz soon moved away from the softer-edged and painterly Pictorialist style, turning toward what came to be known as "straight" (unmanipulated) photographic images, such as *Grasses, Lake George* (plate 38). Still, the Pictorialist aesthetic carried over into the 1920s. In the early platinum prints of the West Coast photographer Imogen Cunningham, such as *Evening on the Duwamish River* (plate 28), an intimate, rather than majestic, mood is evoked in the viewer, who is transported to the edge of a soft-focused, quietly reflective river.

Formal Patterns

The interwar period in Europe was also one of rising industrialization. Artists responded in a variety of ways. Photographer Albert Renger-Patzsch organized the landscape by employing mechanical lines and angles of industry, as in *Industrial Landscape near Essen* (plate 35). August Sander, who, through his multivolume *Menschen des 20. Jahrhunderts (Citizens of the Twentieth Century),* is best known for his portraits, also made several "portraits" of his native countryside. He was introduced to photography when he was given access to the camera of a foreman of an iron mine near his native Rhineland where he worked as a boy. Sander returned to this subject later, placing a camera on the brink of a quarry for *Untitled (Quarry Pit)* (plate 36), as if to re-create one of his first views through a camera.

In the early decades of the twentieth century, photographers continued to explore the possibilities of their medium as it differed from other art forms. Rather than the painterly, softer-focused landscapes of the Pictorialists, they became interested in making images without manipulating the negative or print in the darkroom. For members of f/64, a group of California photographers including Cunningham and Ansel Adams, who followed the tenets Edward Weston outlined in his essay "Seeing Photographically,"[11] the landscape was an ideal subject with which to find the formal in the organic. As if to emphasize the medium's own "natural" qualities of richly toned and graphically organized renderings of whatever the camera confronted, the landscape in the hands of Weston (plates 40, 42, 43) and Adams (plates 41, 44, 45) was calibrated to accentuate—

rather than conceal or diminish—lines, shades, and even textures while illuminating the relative tonal qualities of the gelatin silver print.

In the images of another West Coast–trained photographer, Minor White—who was firmly rooted in the sharply focused and tonally rich camp of his mentor Weston—the photographic medium could be used as a springboard for artistic transformation. In a composition made at Point Lobos, *Eroded Sandstone, Point Lobos State Park, California* (plate 60), the popular site is framed in a way that allows the eye to travel over the rocky surface without a sense of where the horizon is or what, exactly, is being pictured. White advocated the photograph as a vehicle that, through deep, reflective looking, could lead to a meditative, even spiritual, experience. Wynn Bullock's photograph of the same location, *Tide Pool* (plate 55), offers another view. Similar to Weston's through-the-water close-up *Kelp on Tide Pool, Point Lobos* (plate 43), Bullock's more abstract vision of the pools and their surroundings make viewers have to guess whether what they are looking at is close up or far away, a detail or a distant panorama. Bullock's photograph reads almost as a celestial constellation.

Such is the capacity of the landscape subject that the micro, or close-up, view often appears to have been captured through a telescope. Similarly, William A. Garnett's *Rabbit and Cattle Tracks, Carrizo Plain, California* (plate 54), taken from an airplane, could easily appear to be a view through a microscope. Harry Callahan (plates 49, 53) and Aaron Siskind (plates 58, 59) both taught photography at the Institute of Design in Chicago (also known as the New Bauhaus) following its establishment by the artist and photographer László Moholy-Nagy. Both used the landscape to accentuate lines and shapes that can be cropped from nature to form purely abstract images. More innovative cropping can be found in the imagined landscapes of Manuel Álvarez Bravo, such as *Invented Landscape* (plate 47). Álvarez Bravo found some of the rudimentary elements of a landscape—the horizon line, a framing element, the sky—in the shadow of a tree against a white plaster wall with the line of a curb below. The "mouths" of *Las Bocas* (plate 48) refer both to the name of the beach in Mexico where the photograph was made and to the forms of the distant mountains, which, combined with the reflection in the water, seem to create the shape of a closed mouth at the horizon.

Environmental Points

Beginning in the 1960s and 1970s, as the disastrous effects of industrialization became more and more apparent, the natural landscape began to be seen as something in urgent need of preservation. In both its documentary form and in its ability to transform the landscape into something visually transcendent, photography began to be employed to argue in favor of saving a certain landscape for future generations. Eliot Porter (plate 62) and Robert Adams (plates 63, 64), for example, are known for photographs that, whether by accentuating the magnificence or the disrupted nature of a threatened landscape, make a compelling case for taking responsibility for the land. Adams is a central member of what became known as the New Topographics movement. The title, derived from the name of an exhibition held at the George Eastman House International Museum of Photography and Film in 1975, refers to a turning point in how photographers recorded the landscape beginning in the 1970s. Rather than looking for beauty, as Porter did, these photographers applied a more critical and decidedly unromantic eye to changes in the landscape due to human encroachment. Along with the work of Adams and others, the exhibition *New Topographics: Photographs of a Man-Altered Landscape* included the work of the Southern California photographer Lewis Baltz. Baltz's Park City series documented the construction of suburban housing tracts outside Salt Lake City. In *Park City, Element #43* (fig. 4), any picturesque point of view has been discarded for a direct study of dislocated earth, a commentary on

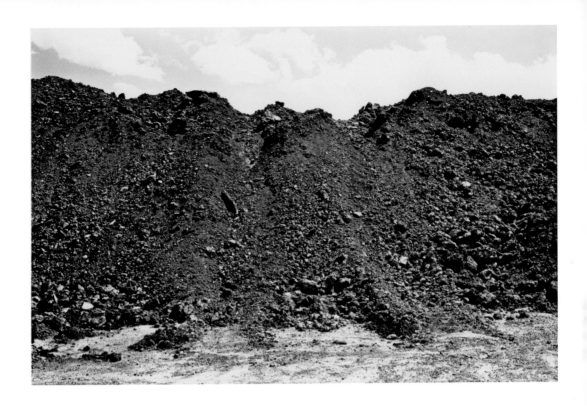

land-razing developments and the resulting loss of nature.

Contemporary Views

Once the landscape had become an established genre in photography, it was available for contemporary artists to explore in more conceptual or critical ways. John Pfahl's portfolio *Altered Landscapes* presents a series of forty dye transfer prints, depicting sites from New York to the Southwest, on which the photographer has "drawn" or imposed his own lines made of colored string. The lines interfere with the natural shape of the landscape while they echo or comment on it. In *Blue X, Pembroke, New York* (plate 68), a field of green fills the frame, preventing any perspectival view. The X created by the contrasting diagonals of

an indigo string playfully, but also meaningfully, emphasizes this loss of perspective. Joel Sternfeld's publication *American Prospects* (1987) also comments on the American landscape, not with a drawn line but with an often ironic, documentary-style gaze. In *Potato Harvest, Aroostook County, Maine, October 1982* (plate 69), a young girl positioned in the lower right turns solemnly toward the camera while a somber-looking field stretches to the horizon and a gray sky.

Another series based on the landscape is John Divola's Isolated Houses (plate 72). Here, Divola documents the phenomenon of minuscule houses constructed in the Southern California desert. The views are taken from a distance that shrinks these small but inhabited structures even further to sizes comparable

to the neighboring shrubs. Captured in vibrant color, Divola's photographs draw out the breathtaking beauty of the desert landscape while the inclusion of the man-made pictures this vast no-man's land with the poignancy of human resilience.

Today's photographers continue to frame their own images around landscapes first captured in the early decades of the medium. The Southern California photographer Karen Halverson makes large color panoramic vistas of the western United States. In *Flaming Gorge Reservoir, Utah/Wyoming* (plate 73), the framing of the awe-inspiring expanse of the gorge, complemented by a sweeping, stormy sky, is reminiscent of the breadth and glory of nineteenth-century photographs. Halverson, however, also chose to include the tall, figurelike viewing platform and telescope, reminding the viewer that this scene has already been discovered. Rather than a personal, exploratory perspective—an artist's confrontation with nature—the landscape is presented as a place of preselected viewpoints. Still, Halverson's camera stands next to the tourists' lookout, subtly refusing to accept its point of view.

The landscape subject is one that has been continually turned to in the history of photography. It has provided the ground from which many camera artists have explored technical debates and aesthetic shifts in their medium. Whether driven by the challenge of reproducing nature in its breadth and perspective or by the myriad possibilities of creating a uniquely resonant artistic experience, the act of depicting nature has inspired photographers from the inception of the medium to the present. Awe-inspiring, breathtaking, magnificent, picturesque, sublime, reflective, critical, transformative—the landscape has engendered a range of viewpoints from which today's photographers will continue to frame their own images.

NOTES

1 Originally the camera obscura was a room with a small aperture on one wall through which a reflection of the exterior would be inverted and projected.

2 Many texts have covered this early period of photographic history. See Quentin Bajac and Dominique Planchon-de Font-Réaulx, *Le Daguerréotype français: Un object photographique* (Paris, 2003); Geoffrey Batchen, *Burning with Desire: The Conception of Photography* (Cambridge, Mass., 1999); Helmut and Alison Gernsheim, *L. J. M. Daguerre: The History of the Diorama and the Daguerreotype* (New York, 1968).

3 The camera lucida is a small prism on a stand through which a reflected image of the draftsman's surroundings can be traced on a piece of paper.

4 William Henry Fox Talbot, "Brief Historical Sketch of the Invention of the Art," in *The Pencil of Nature* (London, 1844), unpaginated.

5 At the lower edge of the sheet, Herschel notes what might have been hard to grasp from merely looking at the drawing. "Level of the ridge on a wide gravelly plain very naked & bare—groups of peasants, etc." On the verso he wrote, "Singular intermixture of the Pyroxene & Dolomite the black and the white rock." See Larry J. Schaaf, *Tracings of Light, Sir John Herschel and the Camera Lucida: Drawings from the Graham Nash Collection* (San Francisco, 1989), p. 114.

6 William Gilpin, "The Art of Sketching Landscape," in *Three Essays: On Picturesque Beauty; On Picturesque Travel; and On Sketching Landscape—To Which Is Added a Poem, on Landscape Painting* (London, 1792), pp. 63–83.

7 The stereograph is composed of two almost identical images mounted on a card; when viewed through a stereoscope, the two images are superimposed to create a three-dimensional scene.

8 The eighteenth-century author and orator Edmund Burke discussed the difference between the sublime and the beautiful—one darker, terrifying, and rugged, the other lighter, nonthreatening, and pleasing to the eye. Edmund Burke, *Philosophical Enquiry into the Origin of Our Ideas of the Sublime and Beautiful* (London, 1757), p. 115.

9 Henry Peach Robinson, *Pictorial Effect in Photography, Being Hints on Composition and Chiaro-oscuro for Photographers* (London, 1869).

10 Peter Henry Emerson, *Naturalistic Photography for Students of the Art* (London, 1889).

11 Edward Weston, "Seeing Photographically," *Complete Photographer* 9, no. 49 (1943), pp. 3,200–06.

PLATES

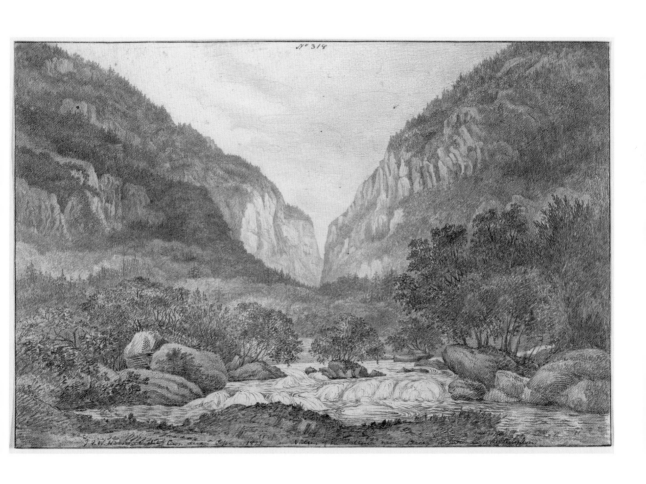

1 SIR JOHN FREDERICK WILLIAM HERSCHEL
 Valley of the Saltina near Brieg at Entrance of the Simplon, 1821

Scientists welcomed the invention of the daguerreo-
type in the 1830s, seeing photography as a valuable
new research tool. In images like *Study of Rocks*
(plate 2), massive geological formations were accurately
recorded, providing evidence for scientific hypotheses
about the earth's formation. The photographer's tight
framing of this pyramidal outcrop and sensitive attention
to shadow lend drama to the depiction, revealing
an equal fascination with the aesthetic potential of the
new medium.

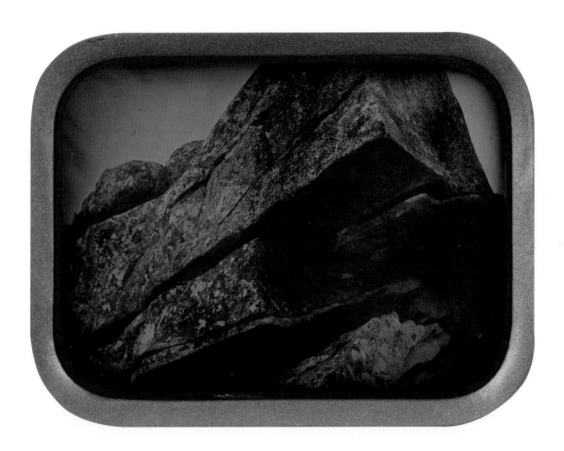

2 UNKNOWN FRENCH PHOTOGRAPHER
Study of Rocks, ca. 1845

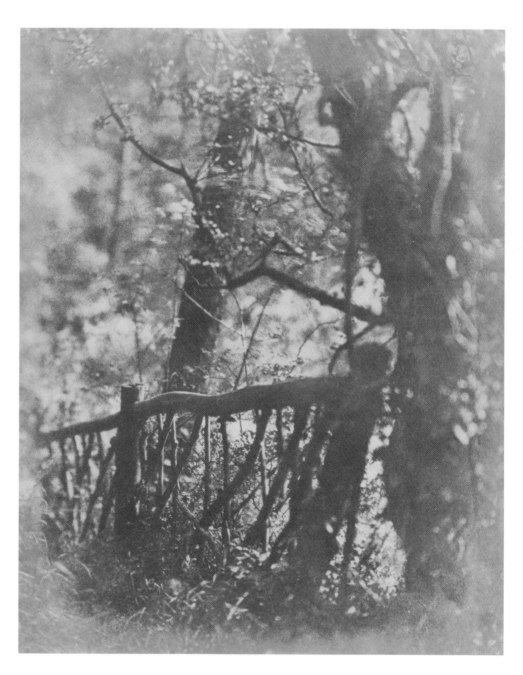

4 DAVID OCTAVIUS HILL
ROBERT ADAMSON
Colinton Wood, 1843–47

A number of early photographers sought to improve aesthetically upon both the precision and technical deficiencies of their medium. André Giroux's father manufactured photographic equipment for Louis-Jacques-Mandé Daguerre. Nevertheless, Giroux was not interested in creating purely photographic recordings of nature. Trained as a painter and inspired by the artists of the Barbizon school, he scratched and drew on his paper negatives to heighten painterly effects. In *The Ponds at Optevoz, Rhône* (plate 5), he depicted the rural landscape of southeastern France, an area that French artists nostalgically turned to for inspiration in an increasingly urban society.

Early collodion-on-glass negatives, which Camille Silvy used for images such as *River Scene, France* (plate 6), were particularly sensitive to blue light, making them unsuitable for simultaneously capturing definition in land and sky. Silvy managed to achieve this synthesis of richly defined clouds and terrain by skillfully wedding two exposures and disguising any evidence of his intervention with delicate drawing and brushwork on the combination negative. The print exemplifies the tension between reality and artifice that is an integral part of the art of photography.

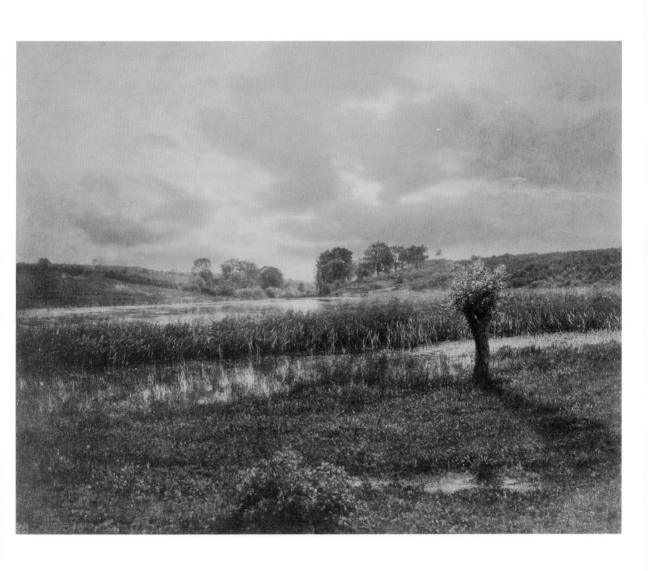

5 ANDRÉ GIROUX

The Ponds at Optevoz, Rhône, ca. 1855

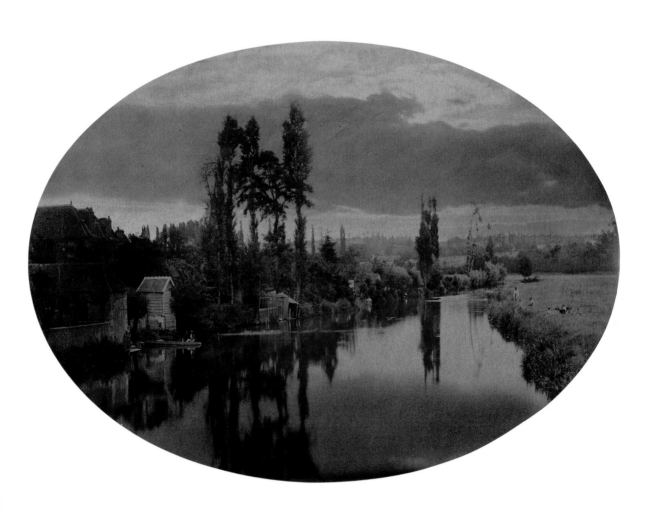

6 CAMILLE SILVY
River Scene, France, negative, 1858; print, 1860s

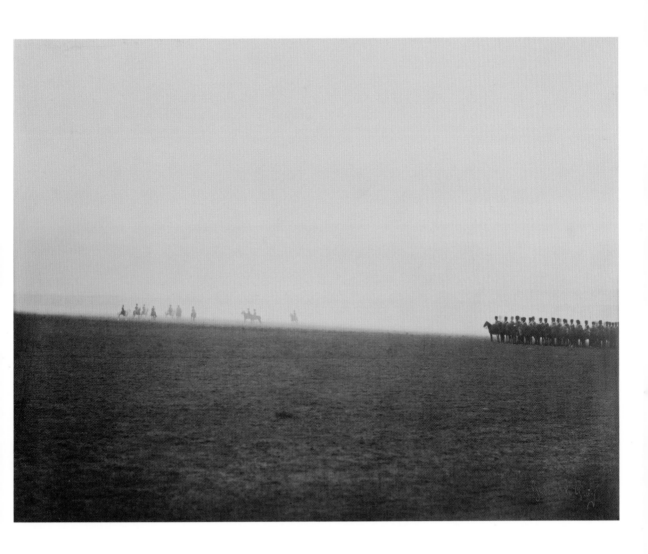

7 **GUSTAVE LE GRAY**
Troops along the Horizon, 1857

Gustave Le Gray found a quiet path in the forest of Fontainebleau (plate 8) and concentrated on the dramatic effects of light streaming through a tightly lined row of tree trunks. Fontainebleau, located about thirty-five miles southeast of Paris, was a popular destination for tourists and landscape artists in the 1800s. It was there that the Barbizon school painters, and later the Impressionists, developed new approaches to nature studies, working outdoors alongside photographers.

GUSTAVE LE GRAY
Futaie (Forest Scene), 1849–52

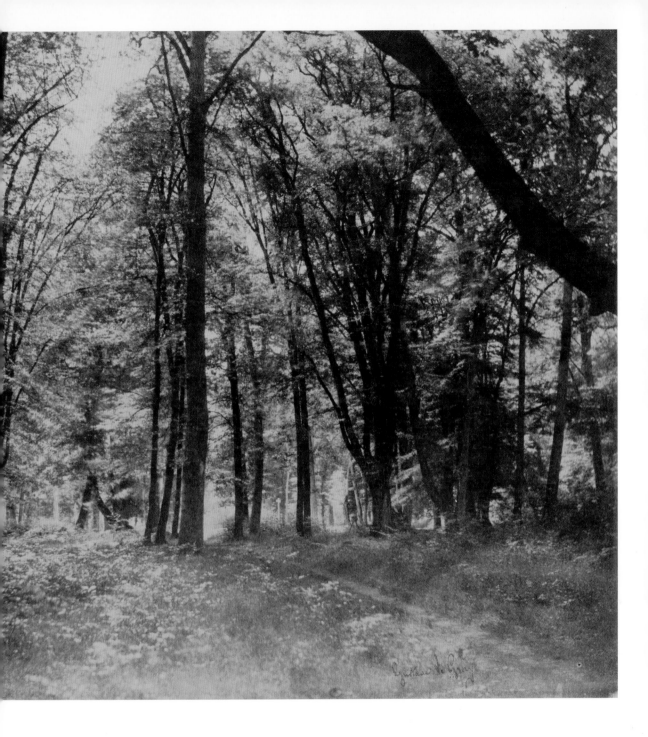

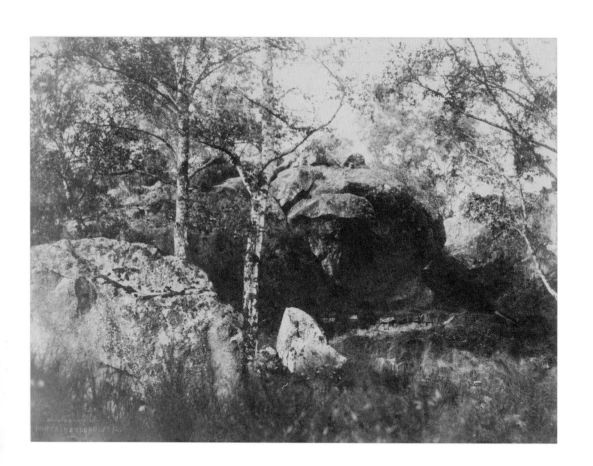

9 **CHARLES MARVILLE**
Fontainebleau, 1854

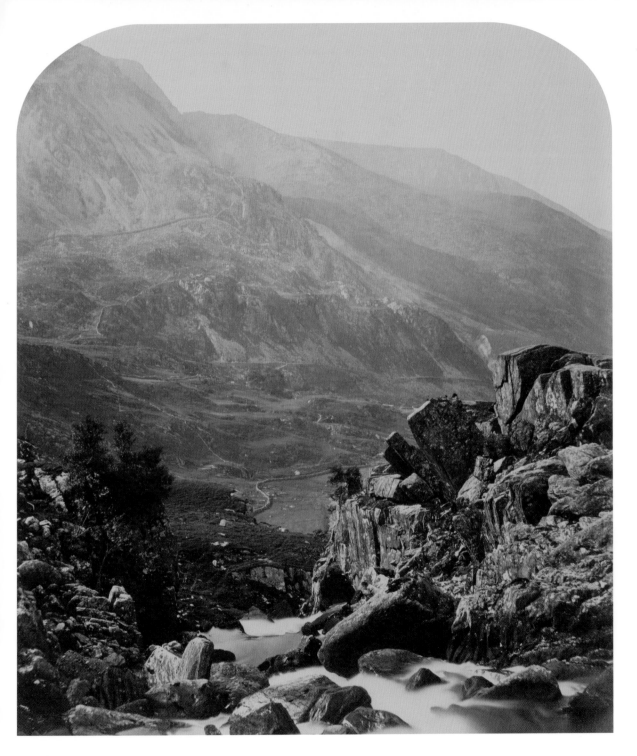

10 **ROGER FENTON**
View from Ogwen Falls into Nant Ffrancon, 1857

Rather than travel to distant lands, many nineteenth-century photographers found inspiration in their environments close to home, capturing the grandeur of nature as well as human command over it. Roger Fenton, a leading English artist-photographer of his time, positioned his camera at the precipice of a rugged mountain pass towering above farmland in the Nant Ffrancon Valley of northern Wales (plate 10). He successfully conveyed the effect of great distance, leading from the falls and sharply defined rocks in the foreground to the serpentine walls of the valley and up the hazy incline beyond. Awe-inspiring topography like this appealed to Victorian viewers, who would have considered the landscape sublime.

The Frenchman Édouard Baldus, by contrast, structured his composition *Entrance to the Donzère Pass* (plate 11) around the perspective lines of the landscape'srailway tracks, embankment, and lakeside path, which converge at the center. Human command over the natural world is underscored not only by the image's strong geometrical organization but also by its subject. Railways and steam-powered locomotives, a major technological development, transformed life and perceptions of distance by dramatically changing the ease and speed with which one could traverse the countryside.

ÉDOUARD BALDUS
Entrance to the Donzère Pass, ca. 1861

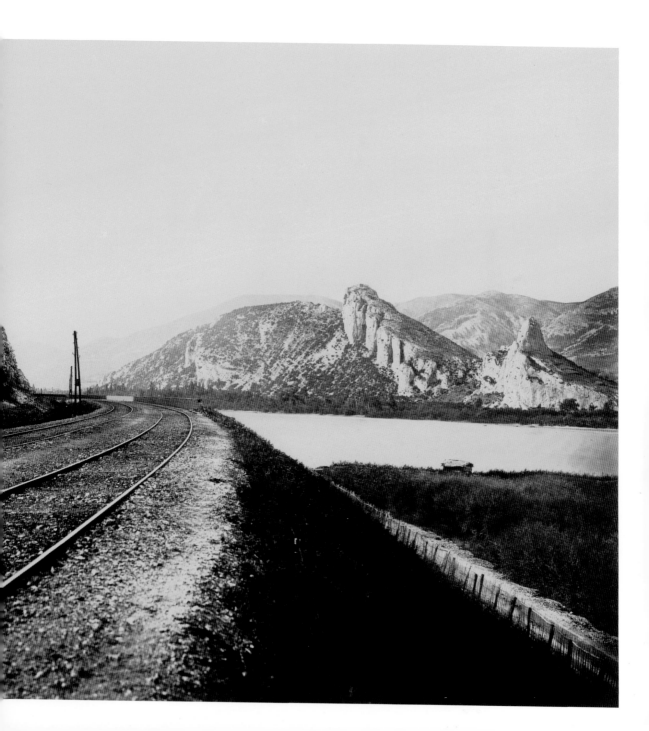

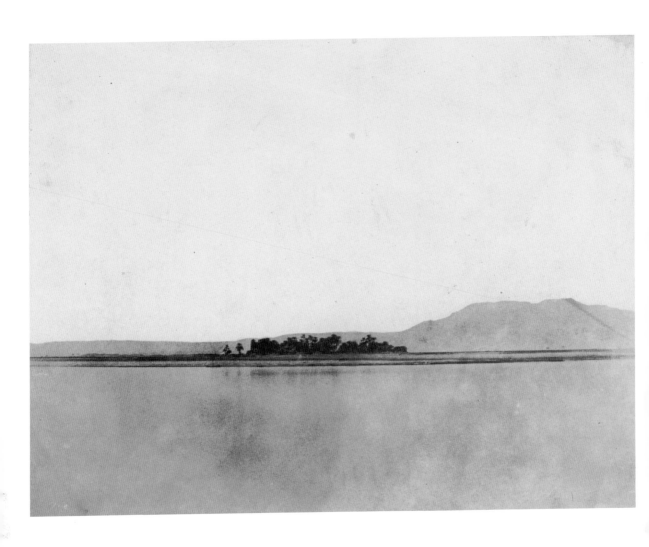

12 **JOHN BEASLY GREENE**
Thèbes, Village de Ghezireh, 1853–54

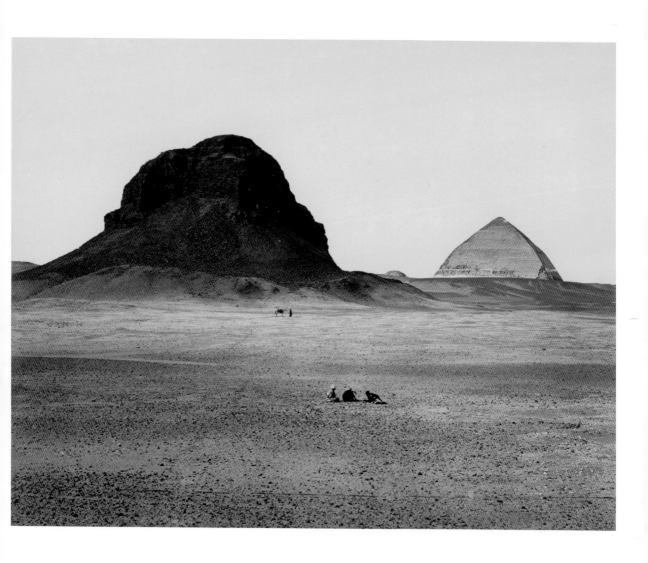

13 FRANCIS FRITH
The Pyramids of Dahshoor, from the East, 1857

In the United States in the 1800s, Prospect Point at Niagara Falls was a popular destination for travelers in search of a transcendent encounter with nature. The falls were revered as a sacred place that was recognized by the Catholic Church in 1861 as a "pilgrim shrine," where the faithful could contemplate the landscape as an example of divine majesty. To make daguerreotypes such as *Scene at Niagara Falls* (plate 14), in which two couples stand facing the spectacle, Platt D. Babbitt installed a canopy for his camera at the site and, from 1853 to 1870, memorialized such moments for visitors.

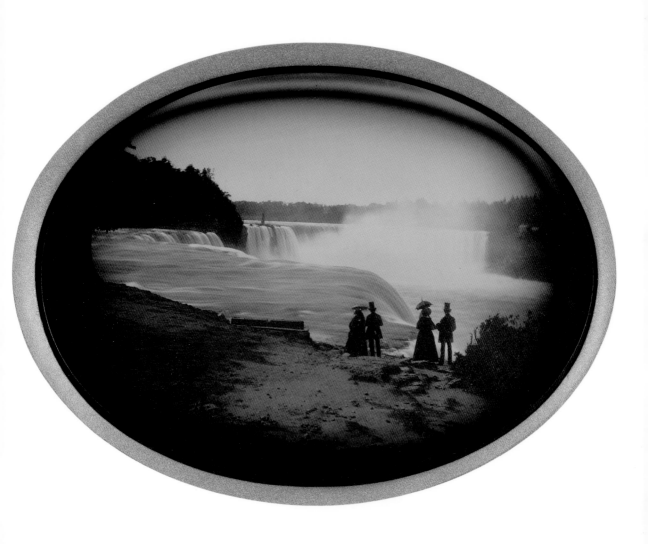

14 PLATT D. BABBITT
Scene at Niagara Falls, ca. 1855

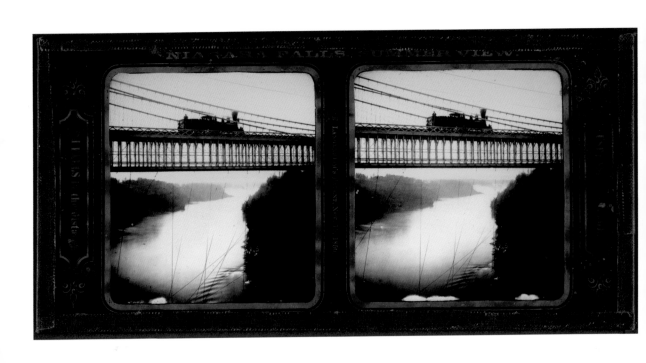

15 **FREDERICK LANGENHEIM**
WILLIAM LANGENHEIM
Niagara Falls, Summer View, Suspension Bridge,
and Falls in the Distance, ca. 1856

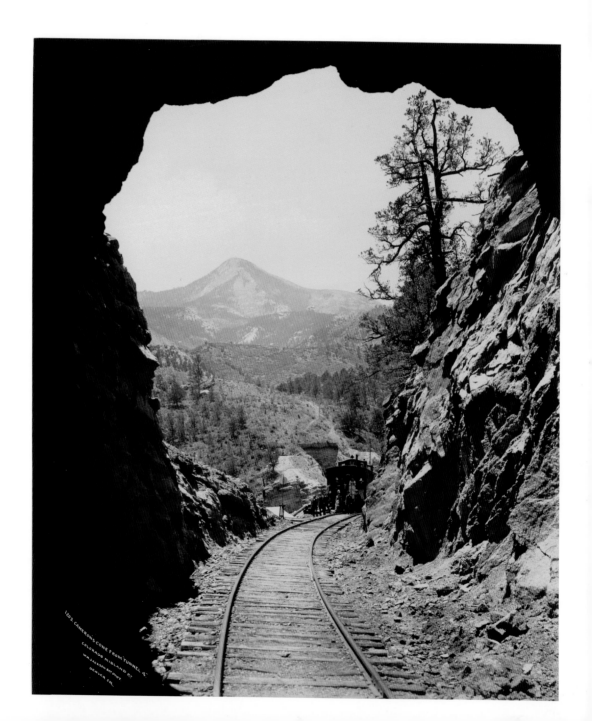

Photographers of the 1860s and 1870s ventured
into the uncharted territories of the American West,
photographing the frontier, often with remarkable
results. A journey into Yellowstone Valley required
several days of arduous travel via rail, stagecoach, and
mule train when William Henry Jackson visited there
in 1870. His pictures, combined with extensive reports
from the government-sponsored expedition with
which he traveled, moved the United States Congress
to designate the area a national park in 1872. Jackson
captured the geyser Old Faithful (plate 17) with
a mammoth-plate camera. He included a figure at
lower left to convey the enormity and heighten
the romanticism of this awesome natural phenomenon.

Timothy O'Sullivan honed his skills as a pho-
tographer during the Civil War. In 1867 he joined the
Geological Exploration of the Fortieth Parallel, the first
governmental survey of the West. His pictures were
intended to provide information for expanding railroads
and industry, yet they demonstrate his eye for lyricism.
Moving through the untamed Nevada wilderness, he
stopped his mobile darkroom—a horse-drawn wagon—
and photographed it amid sand dunes, creating a
heroic image of exploration that is emblematic of the
nineteenth-century American identity (plate 18).

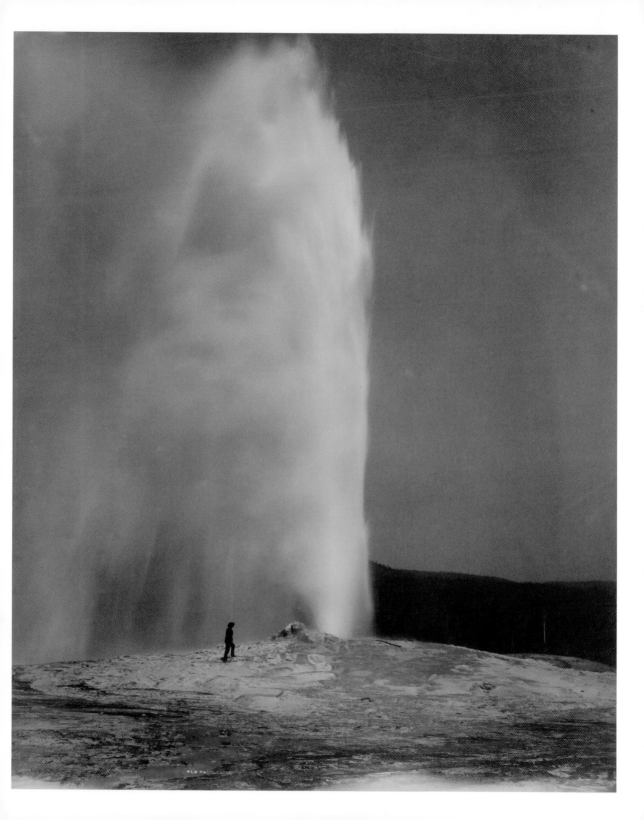

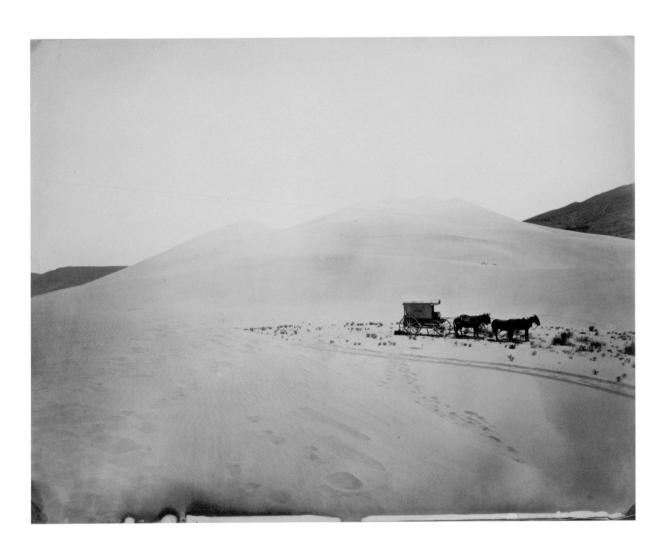

18 **TIMOTHY H. O'SULLIVAN**
Desert Sand Hills near Sink of Carson, Nevada, 1867

19 **TIMOTHY H. O'SULLIVAN**
Ancient Ruins in the Cañon de Chelle, New Mexico, in a
Niche Fifty Feet above Present Cañon Bed, 1873

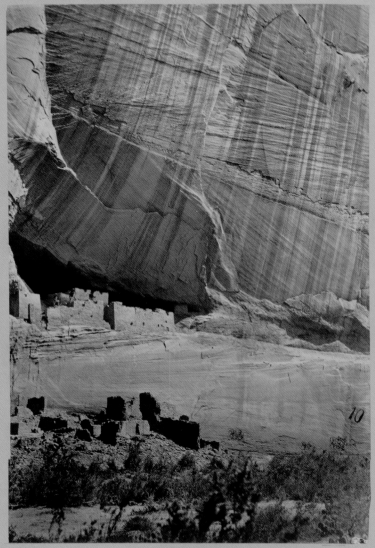

T. H. O'Sullivan, Phot.

N°. 11

ANCIENT RUINS IN THE CAÑON DE CHELLE. N. M.

In a niche 50 feet above present Cañon bed.

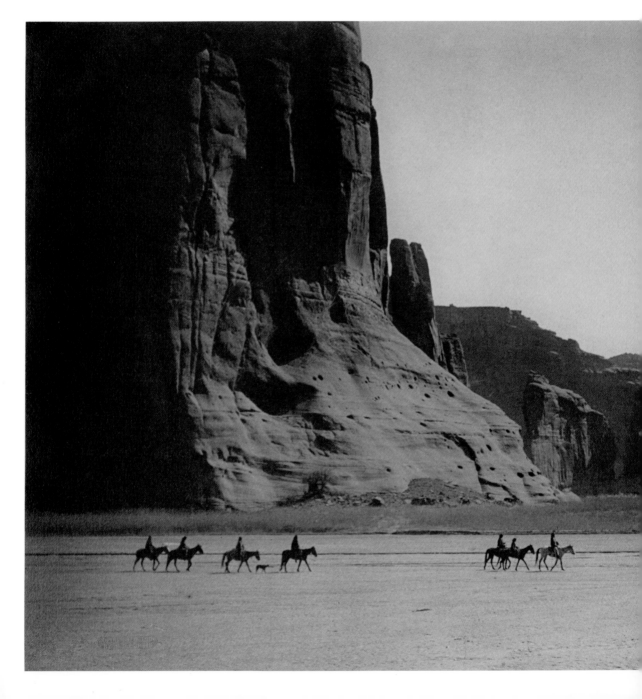

Edward S. Curtis's depiction of Navajos crossing the desert on horseback (plate 20), their graceful silhouettes at the base of Arizona's Canyon de Chelly, betrays a romantic view of the past. As the western United States developed, Curtis endeavored to record the vanishing cultures of the land's original inhabitants. His work, which was sometimes choreographed and often printed in platinum—a luxurious medium associated with artistic movements of the day—combines both documentary and aesthetic approaches.

20 **EDWARD S. CURTIS**
Canyon de Chelly, 1904

21 **HENRY P. BOSSE**
Wingdams below Ninninger, Minnesota, 1891

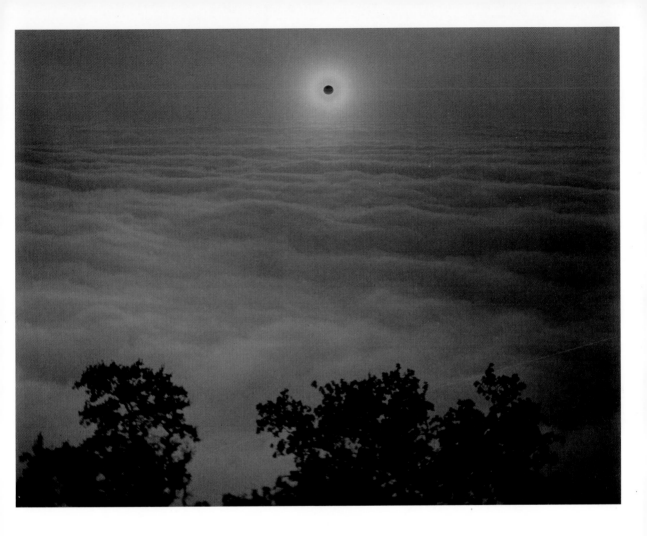

22 **CARLETON WATKINS**
Solar Eclipse, January 1, 1889

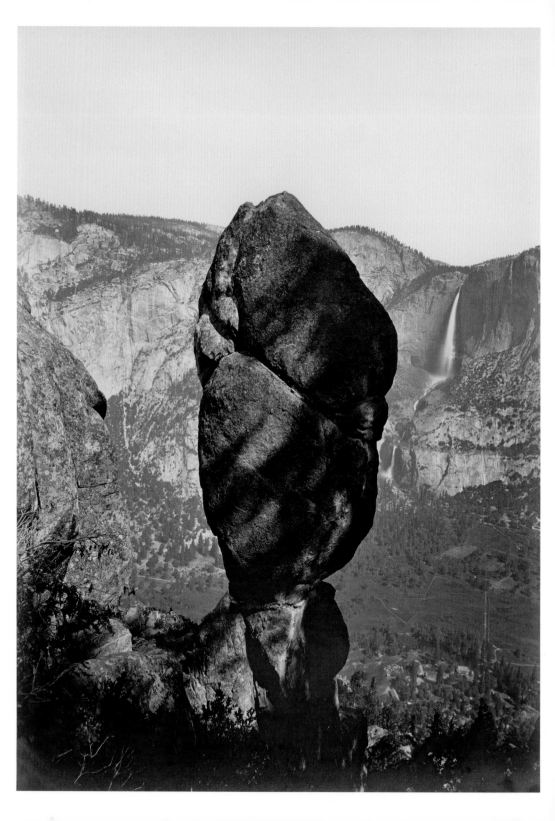

23 **CARLETON WATKINS**
Agassiz Rock and the Yosemite Falls,
from Union Point, ca. 1878

24 **EADWEARD J. MUYBRIDGE**
Valley of the Yosemite, from Rocky Ford, 1872

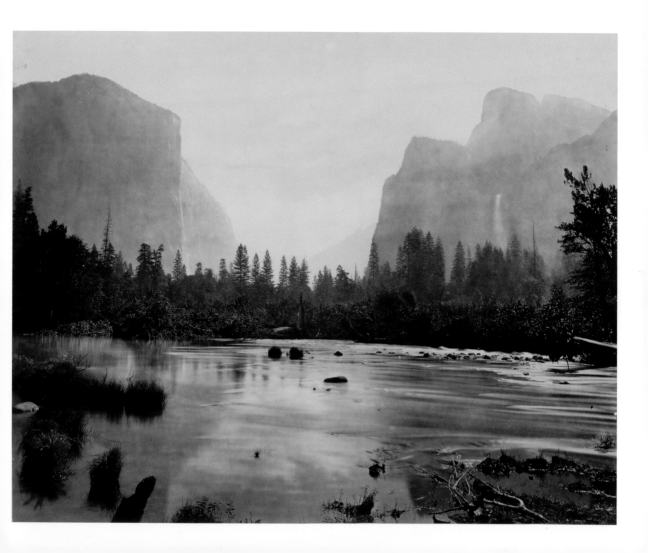

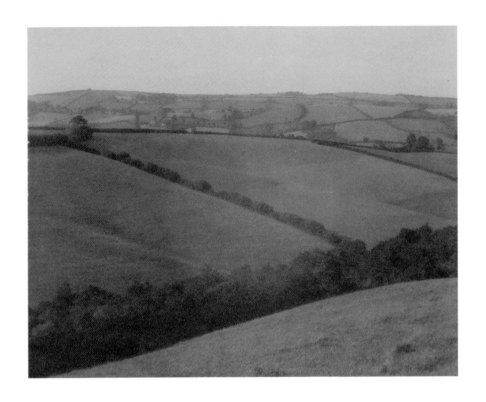

25 **LAURA GILPIN**
A Devonshire Pattern, 1922

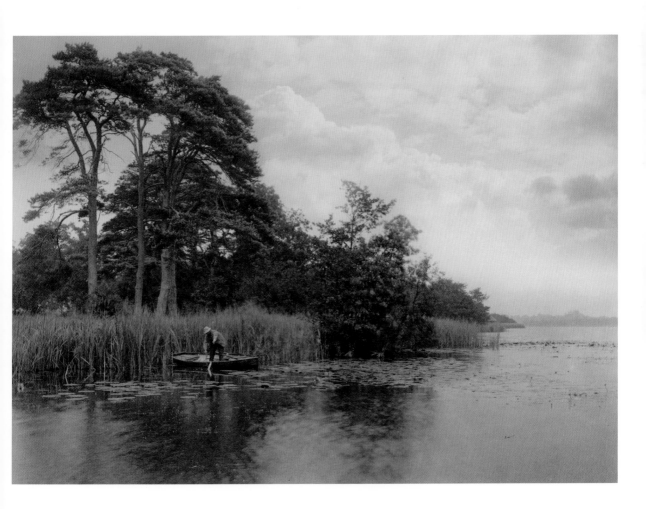

26 **PETER HENRY EMERSON**
The Haunt of the Pike, 1886

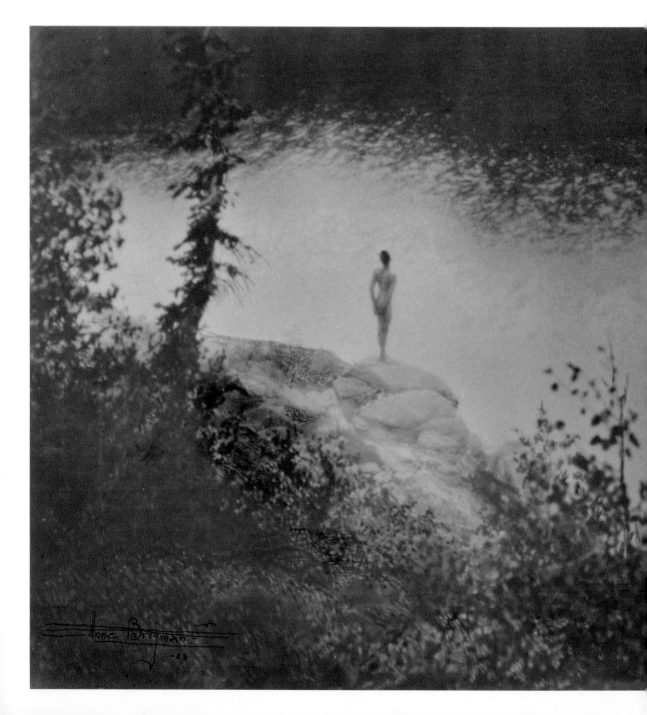

As a Pictorialist, Anne W. Brigman favored a poetic rather than a clearly descriptive approach to landscape, emphasizing formal elegance, elusive symbolism, and craftsmanship. Her romantic, soft-focus work celebrates a spiritual communion between humans and nature, as in this study of a nude figure enveloped within the gentle, undulating forms of her lakeside surroundings (plate 27).

27 **ANNE W. BRIGMAN**
Figure in a Landscape, 1923

28 **IMOGEN CUNNINGHAM**
Evening on the Duwamish River, ca. 1911

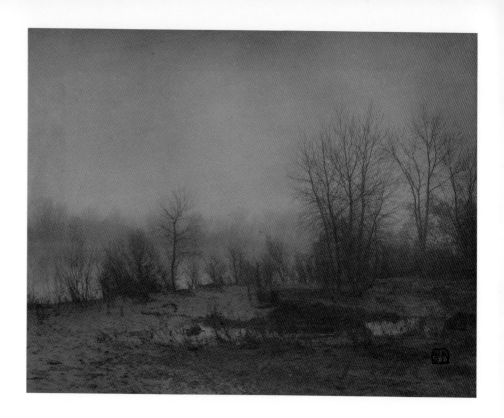

29　WILLIAM EDWARD DASSONVILLE
Untitled (Trees near Sacramento), ca. 1900

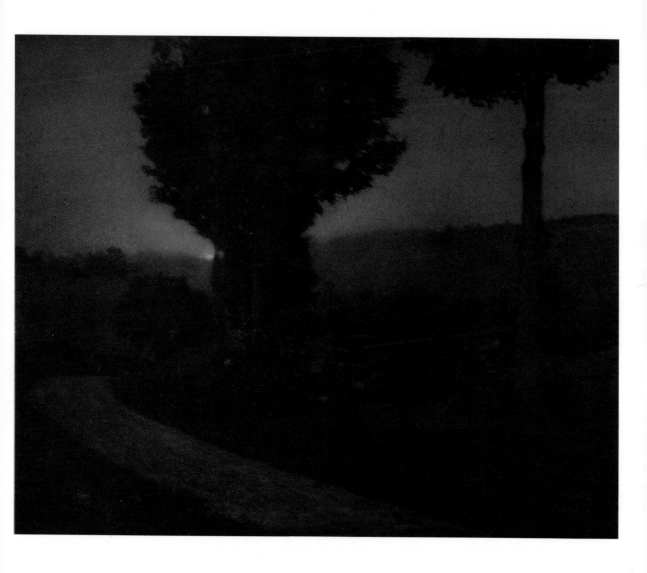

30 **EDWARD STEICHEN**
Pastoral, Moonlight, negative, 1904; print, 1906

31 **ANDRÉ KERTÉSZ**
Camera in Landscape, 1917–25

32 **LEE MILLER**
Portrait of Space, 1937

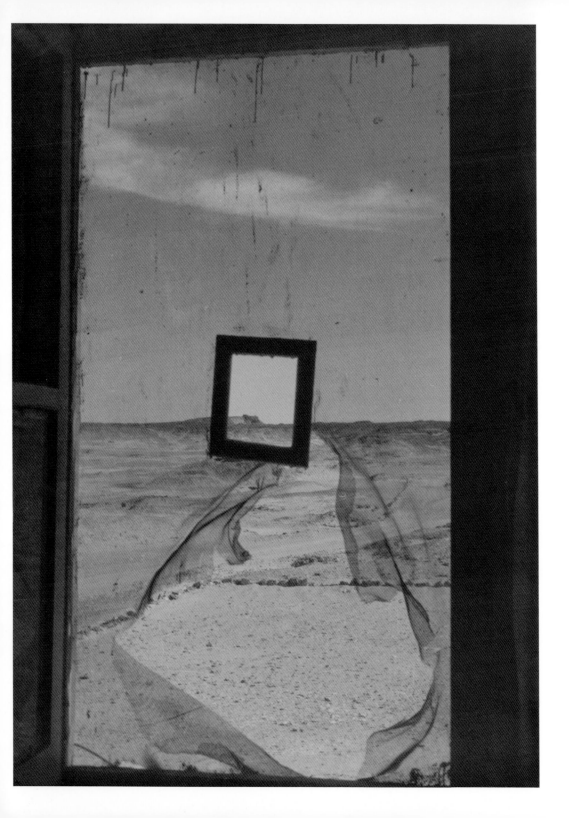

33 **ALEXANDER RODCHENKO**
Wald von Puschkino, Kiefern (Forest at Pushkino, Pines),
negative, 1929; print, 1979

34 **MAN RAY**
Untitled (Tree Trunk), 1928

35 ALBERT RENGER-PATZSCH
Industrial Landscape near Essen, 1930

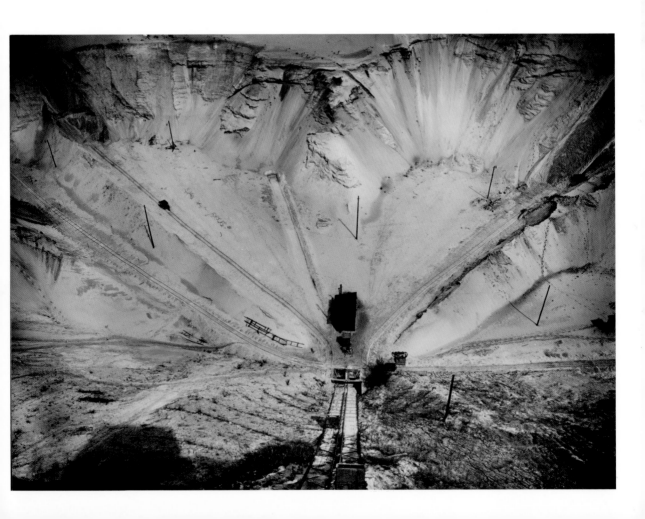

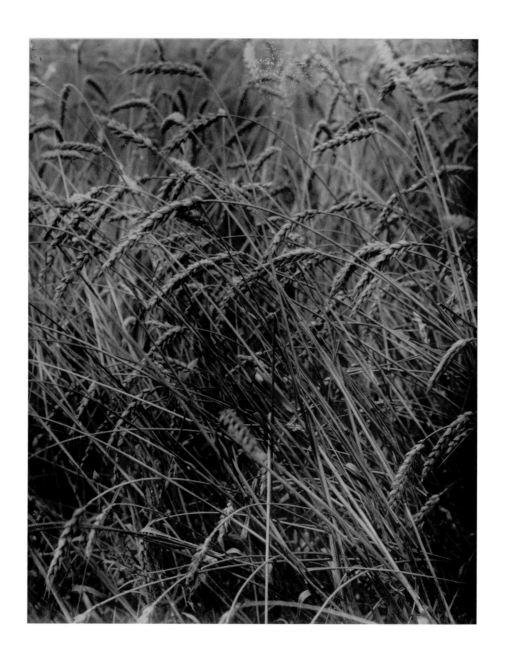

37 **EUGÈNE ATGET**
Blé (Wheat), 1900

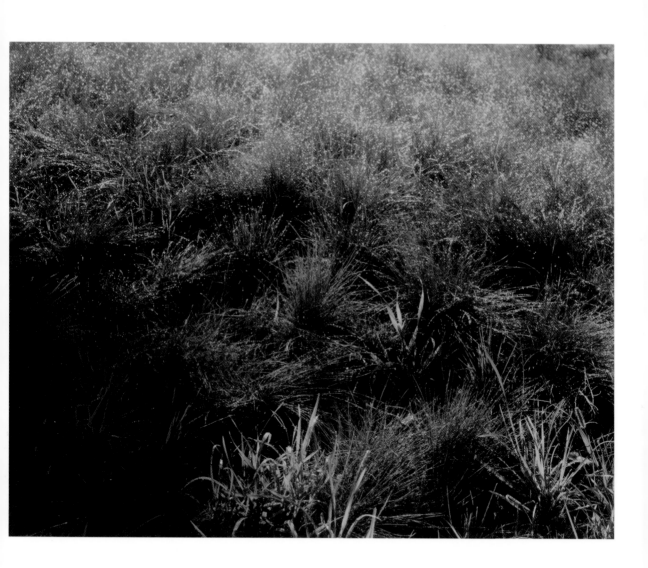

38 **ALFRED STIEGLITZ**
Grasses, Lake George, 1933

Shooting into the sun, Eugène Atget framed a circular reflecting pool behind the bold silhouette of a tree, allowing alternating bands of light and dark to articulate his composition *Saint-Cloud* (plate 39). His straightforward approach to Saint-Cloud Park, on the outskirts of Paris, diverged from the heavily manipulated Pictorialist style of Anne W. Brigman (plate 27). Atget was admired by Modernist photographers such as Berenice Abbott, who printed and popularized his work after his death.

The natural world was an important subject for Modernist photographers in the United States. A leader of the movement, Edward Weston used a sharp-focus approach to transform everyday subjects into extraordinary explorations of form. In *Sand Dunes, Oceano, California* (plate 40), he elegantly organized deep shadows cast beneath brightly lit crests of sand, creating a composition in which space and scale are largely absent, and the image is allowed to hover between pure abstraction and recognizable landscape.

Nature was a source of optimism and inspiration for Ansel Adams. A quintessentially American landscape photographer, he is known for his timeless, idyllic depictions of the natural environment. In *El Capitan, Yosemite* (plate 41), he captured the quiet drama of afternoon sunlight illuminating El Capitan, which rises like a cathedral from the Yosemite Valley floor. While Adams did not make pictures specifically for conservation groups, he was a supporter of their efforts and permitted his pictures to be employed in their promotion.

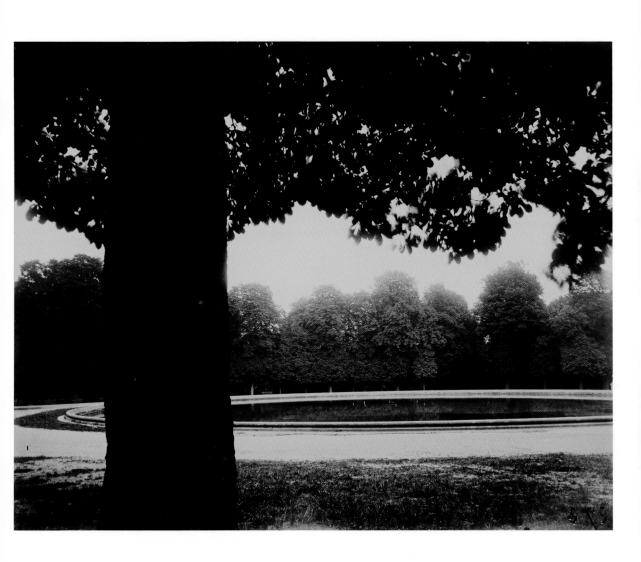

39 **EUGÈNE ATGET**
Saint-Cloud, negative, 1926; printed later by Berenice Abbott

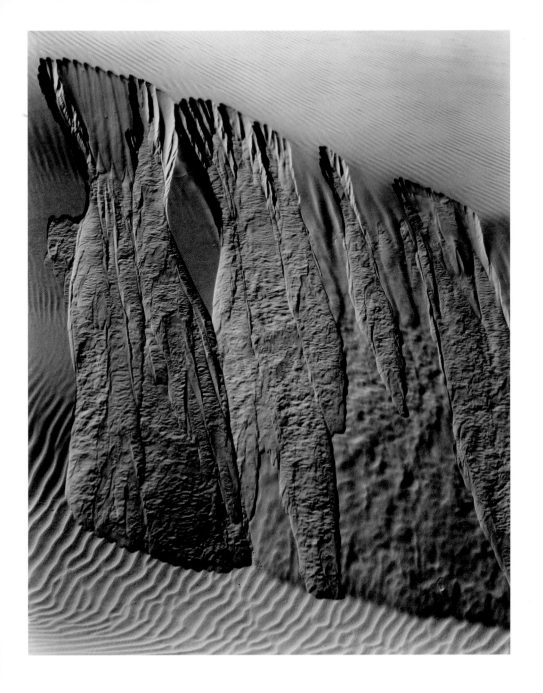

40 **EDWARD WESTON**
Sand Dunes, Oceano, California, 1934

41 **ANSEL ADAMS**
El Capitan, Yosemite, negative, 1938; print, 1950

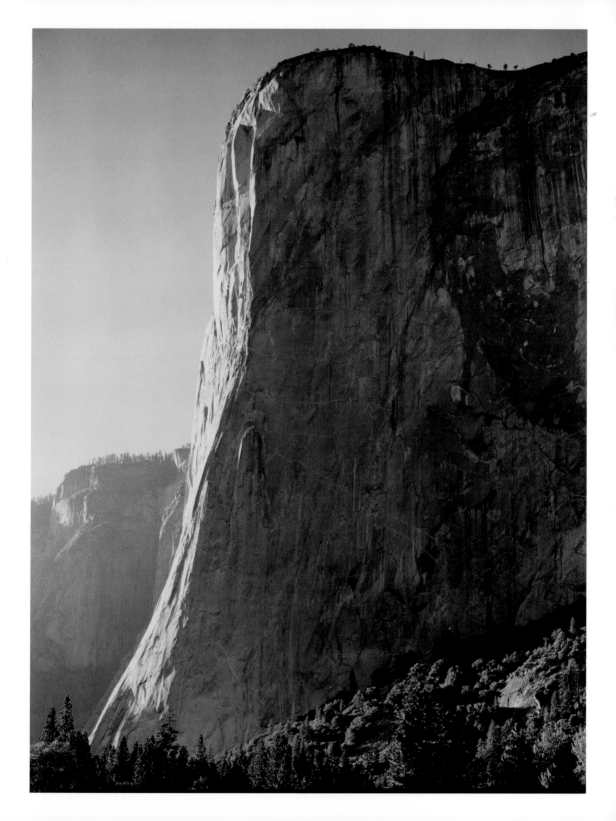

42 **EDWARD WESTON**
Point Lobos, November 1938

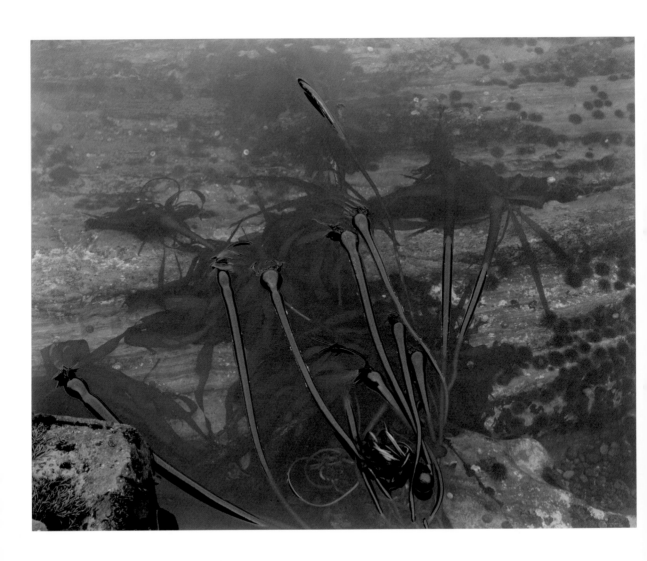

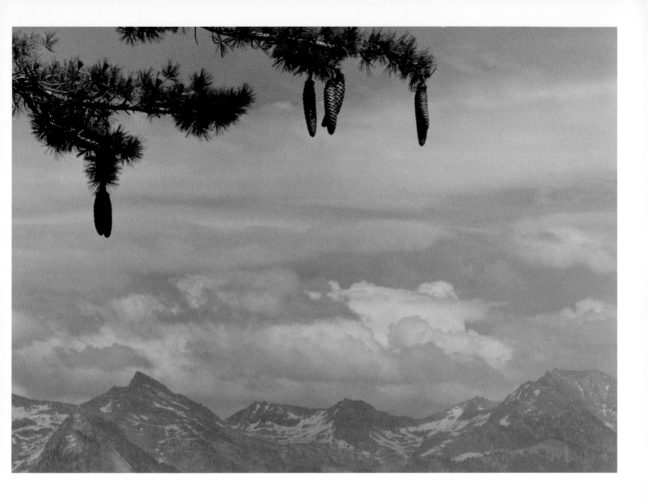

44 **ANSEL ADAMS**
Sugar Pine Cones, negative, 1925–30; print, 1931–32

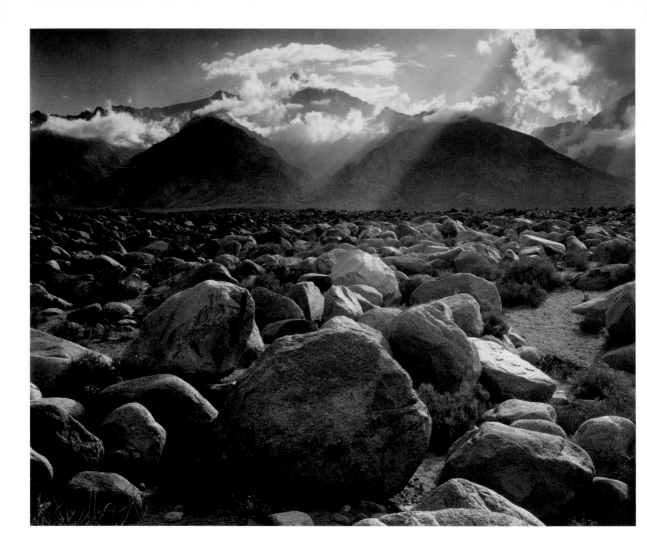

45 **ANSEL ADAMS**
Mt. Williamson from Manzanar, California, 1944

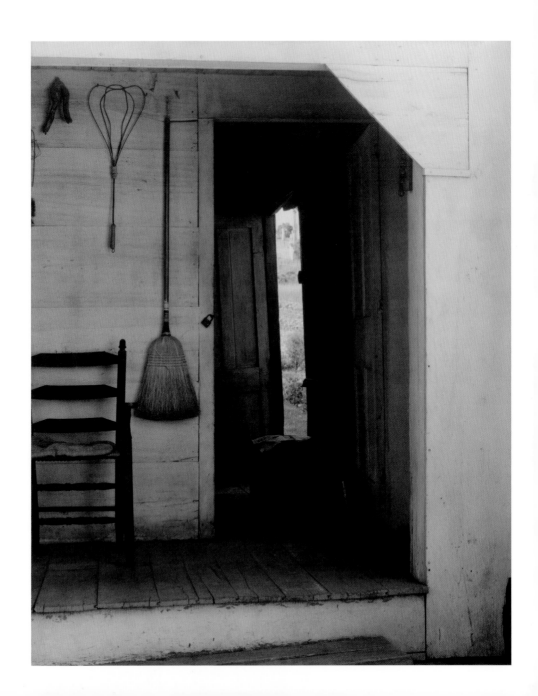

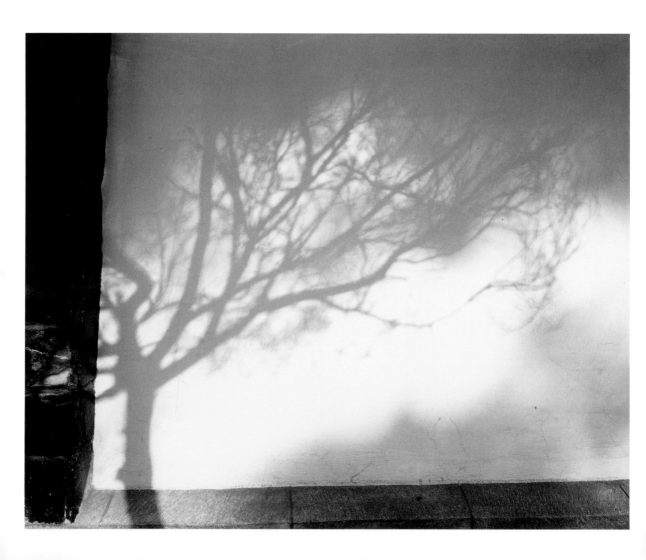

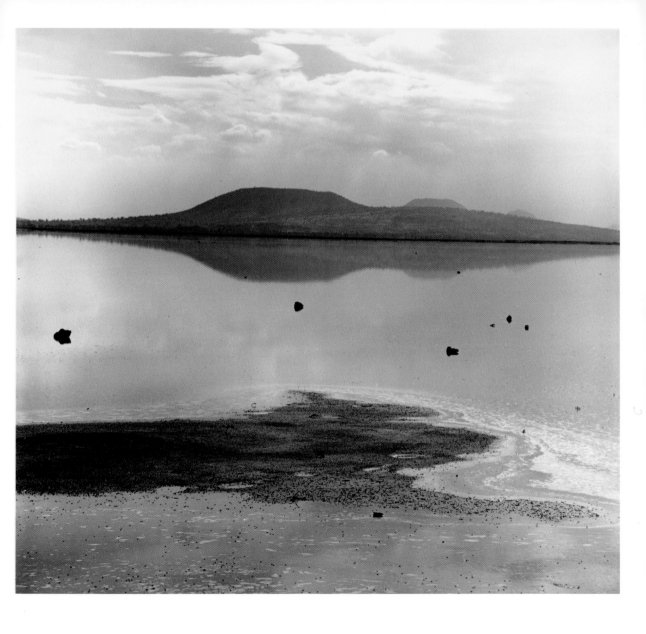

48 MANUEL ÁLVAREZ BRAVO
Las Bocas (The Mouths), 1963

Starting in the 1940s, a new generation of photographers responded to the visual currents of their Modernist teachers and predecessors with fresh perspectives. Harry Callahan referred to *Detroit* (plate 49), made shortly after an inspiring encounter with Ansel Adams, as his first good picture. Unlike Adams's dramatic landscapes, Callahan's composition focuses on an overlooked pedestrian scene in his native Detroit. Raising the horizon line, the artist achieved a delicate, calligraphic interplay among the reeds and telephone poles and their reflections across the surface of a bog.

An admirer of Alfred Stieglitz and Edward Weston, Frederick Sommer took up large-format photography in 1938. Tilting his camera downward and eliminating the horizon line, he filled the frame of *Colorado River Landscape* (plate 50) with visual information. His image emphasizes the abstract qualities of line and texture along the Colorado River, which is barely discernible beyond the foreground bluffs. The photograph has the potential to momentarily disorient a viewer searching for a recognizable subject.

Inspired by a cross-country flight in 1945, William A. Garnett learned to fly his own airplane and devoted himself to making aerial pictures of the landscape. His work reveals a beauty and order in the natural environment that cannot be seen from an earthbound perspective. In *Sandbars, Cape Cod, Massachusetts* (plate 51), he captured a wide expanse of sandbars along Cape Cod, including a white sailboat (at upper right) to ground the nearly abstract image with scale and perspective.

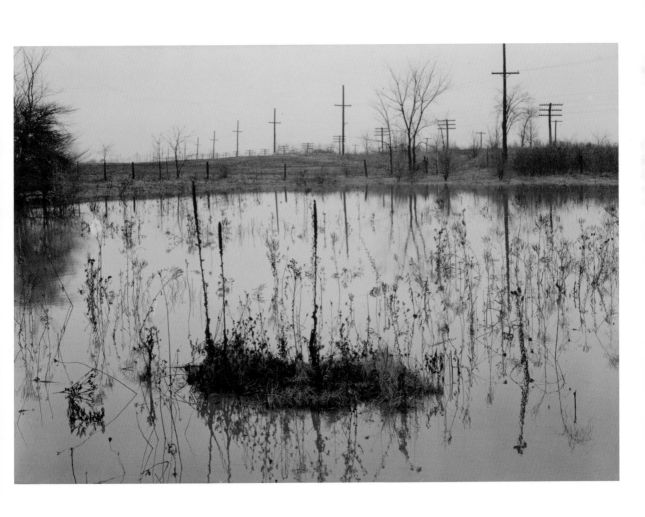

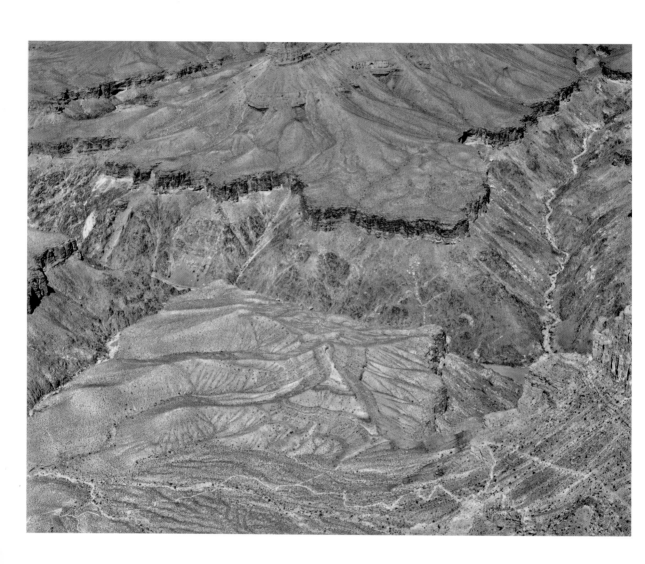

50 FREDERICK SOMMER
Colorado River Landscape, 1940

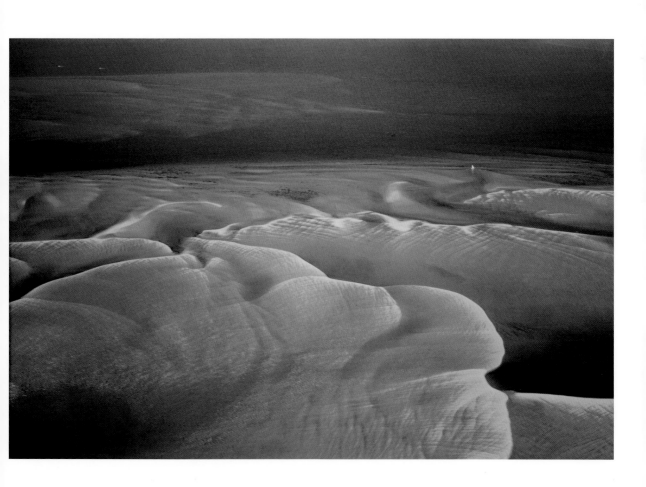

51 **WILLIAM A. GARNETT**
Sandbars, Cape Cod, Massachusetts, 1966

FREDERICK SOMMER
Glass, 1943

53 **HARRY CALLAHAN**
Chicago, ca. 1948

54 **WILLIAM A. GARNETT**
Rabbit and Cattle Tracks, Carrizo Plain, California, 1955

55 **WYNN BULLOCK**
Tide Pool, 1957

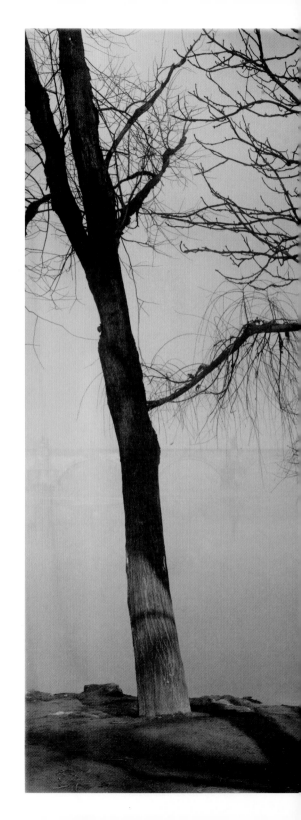

JOSEF SUDEK
A Walk on Kampa Island, 1956

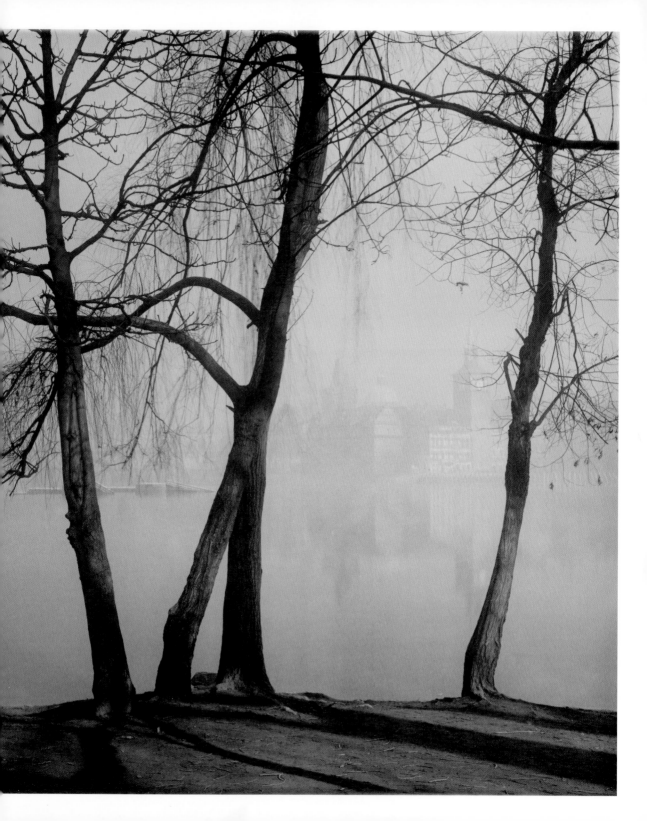

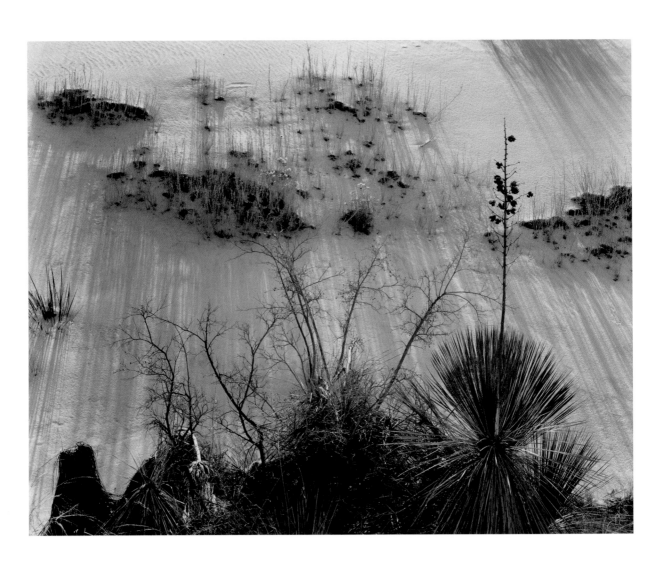

57 **BRETT WESTON**
White Sands, New Mexico, 1947

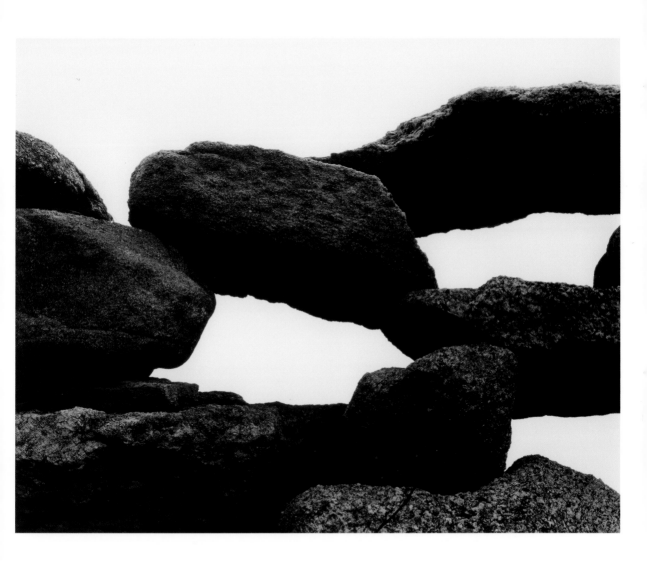

58 **AARON SISKIND**
Martha's Vineyard 111B, 1954

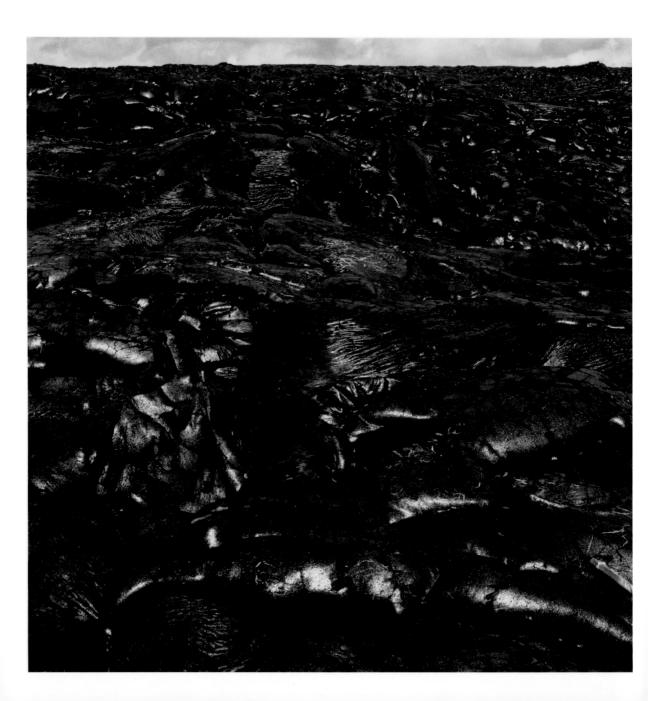

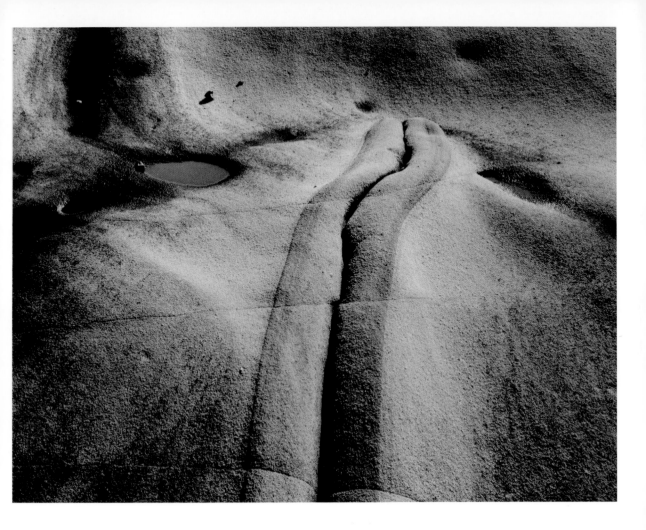

59 **AARON SISKIND**
Volcano 129, 1980

60 **MINOR WHITE**
Eroded Sandstone, Point Lobos State Park, California, 1950

Dedicated to using the camera toward social engage-
ment, Dorothea Lange spent several years documenting
Depression-era conditions. In her efforts to record the
effects of the economic decline on migrant labor, in
The Road West (plate 61), Lange focused on a western
expanse dominated by Highway 54. Stretching deep into
the distance through a seemingly desolate landscape,
the road was one that many families took west on their
exodus from rural dust bowl conditions in Oklahoma.

61 **DOROTHEA LANGE**
The Road West / Highway to the West, U.S. 54 in Southern
New Mexico, negative, 1938; print, 1965

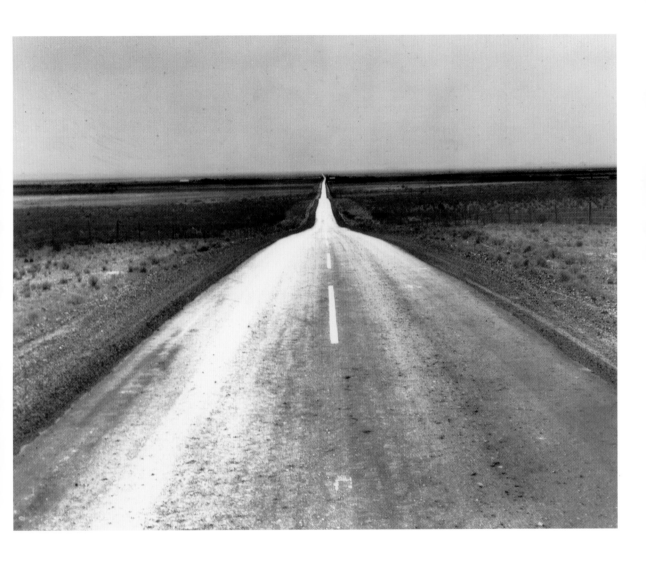

Eliot Porter's "portraits" of natural subjects in the
lush color of dye transfer prints are meant to inspire
preservation of the land for its beauty (plate 62).
Between the late 1930s, when the first popular color
film was invented, and the mid-1970s, Porter dedi-
cated himself to photographing nature. Remarkable
for its subtle luminosity, his work was published in
concert with conservation efforts and contributed to
widespread acceptance of color photographs as art.

Robert Adams, in contrast, presents a landscape
of unconventional allure: a quarried mesa scarred
with a serpentine network of tire tracks (plate 63).
Focusing on spaces that are not typically revered
for their splendor—but where many people live and
work—Adams draws attention to the dignity of the
ordinary landscape and the effects of human incursions
on it (plate 64). His images and writing encourage
responsible stewardship of the environment as a
whole, not just those areas set aside for preservation
in national parks.

Aspens, Elk Mountain Road, New Mexico, 1972

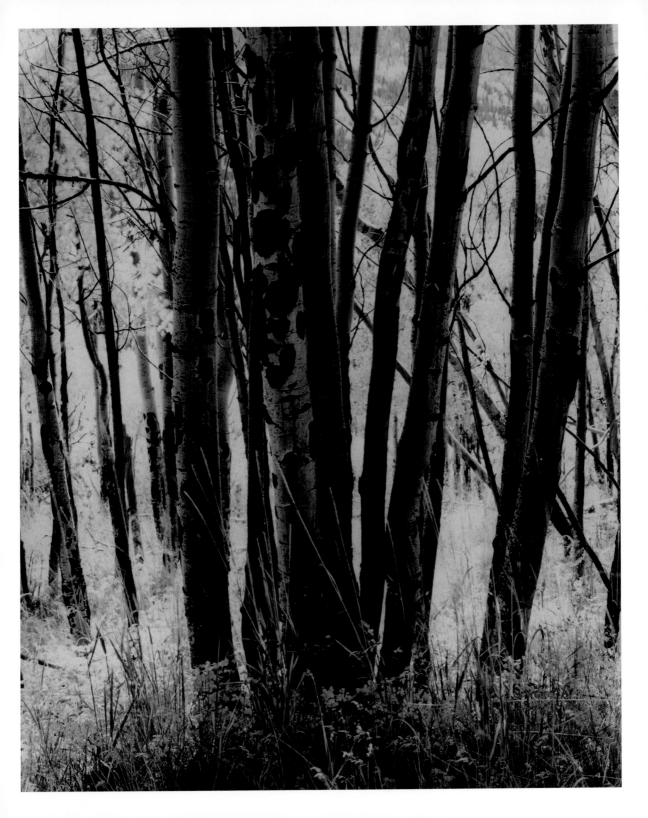

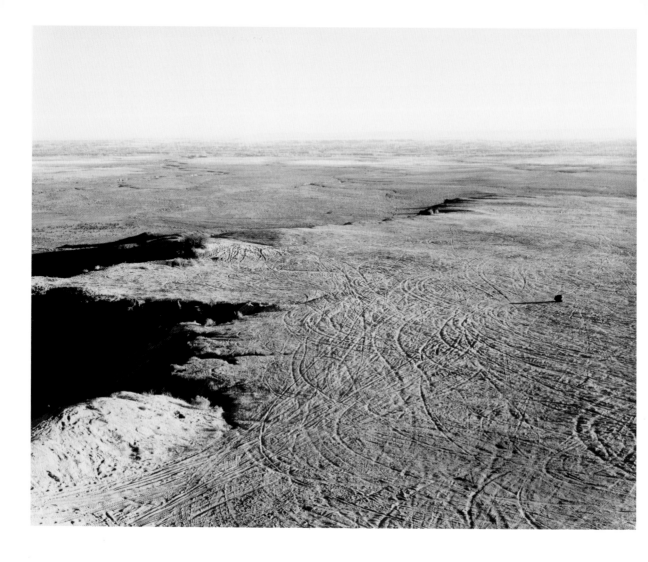

63 **ROBERT ADAMS**
Quarried Mesa Top, Pueblo County, Colorado, 1978

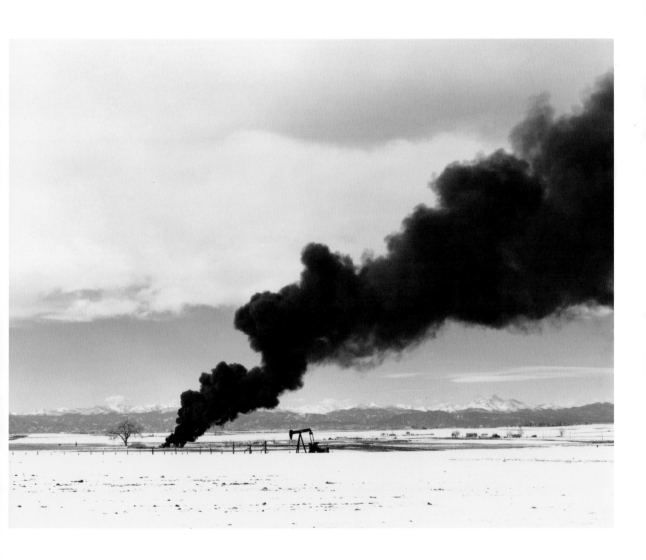

Employing a complex technique of photomontage, Jerry Uelsmann combined multiple negatives depicting the natural world to achieve an evocative artistic statement. In *Navigation without Numbers* (plate 65), a beach landscape, overlaid surreally with hands and an interior scene, becomes a subject for the contemplation of artistic discovery. "I am involved with a kind of reality that transcends surface reality," he noted in his essay "Random Thoughts on Photography." "More than physical reality, it is emotional, irrational, intellectual, and psychological."

While Uelsmann explored landscapes of the mind, images made during the Apollo lunar missions provided views to a landscape that previously could only have been imagined. Like the United States government's surveys of the West in the 1800s, space missions—and the pictures that resulted—served a combination of scientific and political ends. In *Astronaut, Lunar Surface* (plate 66), NASA pilot James Irwin used a specially outfitted, chest-mounted camera to photograph his Apollo 15 commander, David Scott, performing an experiment.

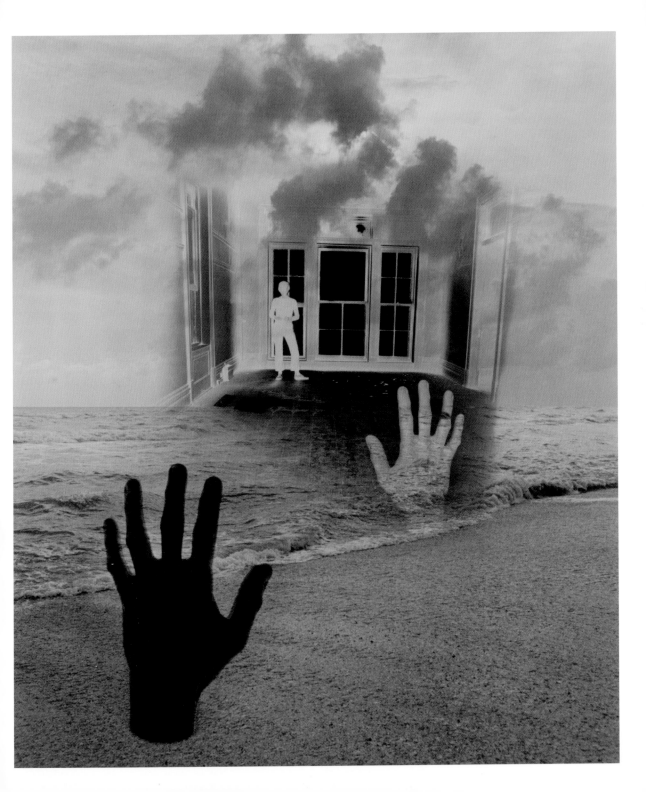

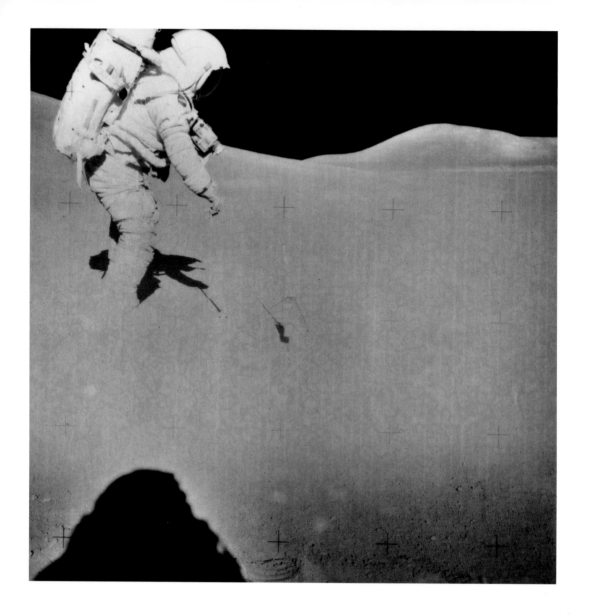

66 **JAMES IRWIN FOR NASA**
Astronaut, Lunar Surface, August 1, 1971

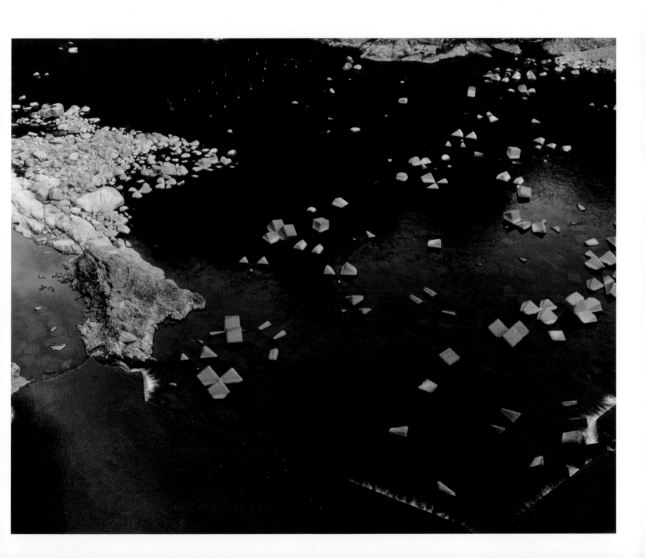

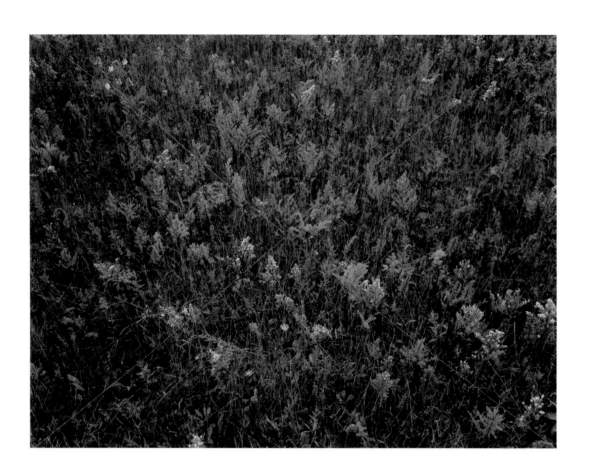

68 JOHN PFAHL
Blue X, Pembroke, New York, 1975

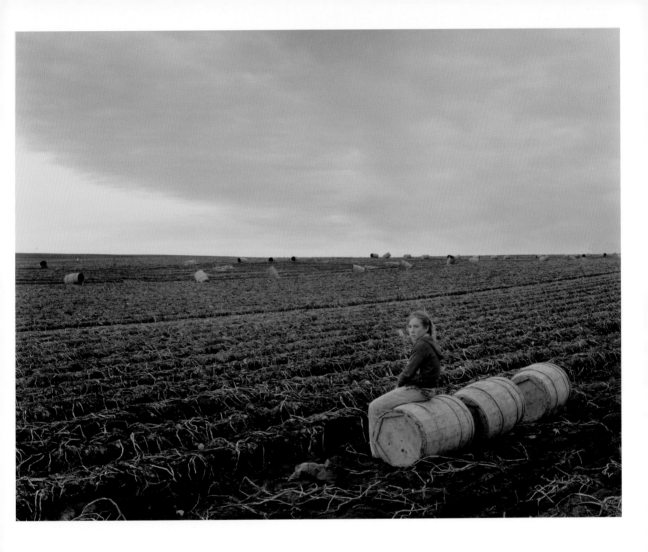

69 **JOEL STERNFELD**
Potato Harvest, Aroostook County, Maine, October 1982,
negative, October 1982; print, November 1986

Artists working more recently have devised new interpretations of traditional landscape subjects captured marvelously by photographers such as Ansel Adams and Carleton Watkins before them. In *Mount Rainier, Washington* (plate 70), Virginia Beahan and Laura McPhee take a witty, postmodern approach that recognizes the commodification of the picturesque in a painted landscape hung behind a table in a restaurant. Beahan and McPhee have also delved into the landscape as a site of human history and conflict. With the High Sierra as a backdrop, rusty remnants of the Manzanar relocation camp (plate 71), used to detain Japanese Americans during World War II, occupy the foreground. In the middle ground stand the desiccated trunks of an orchard, probably the outgrowth of an 1860s settlement that was abandoned after the land's water was diverted in the 1920s to irrigate Los Angeles. That settlement, in turn, had uprooted a community of Paiute Indians, who had lived there for generations.

70 **VIRGINIA BEAHAN**
LAURA MCPHEE
Mount Rainier, Washington, 2000

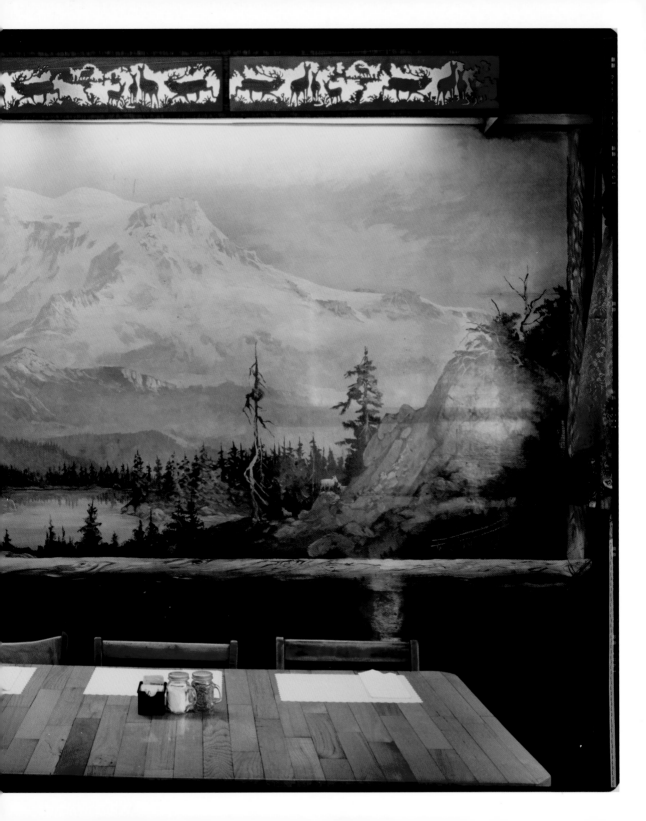

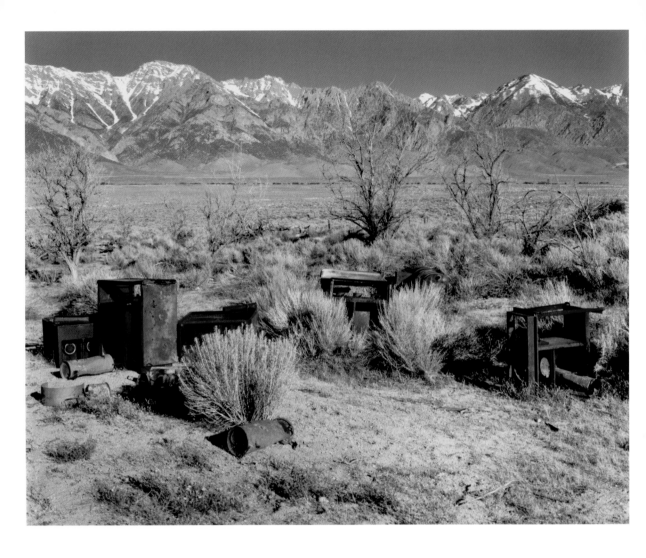

71 VIRGINIA BEAHAN
 LAURA MCPHEE
 Apple Orchard, Manzanar Japanese American Relocation
 Camp, Owens Valley, California, 1995

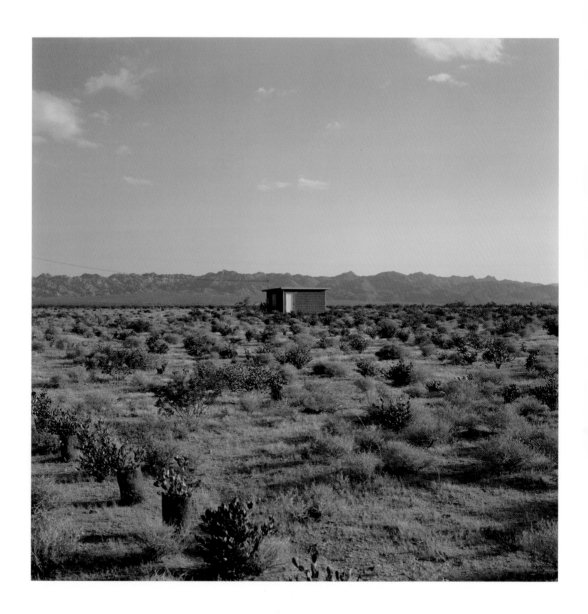

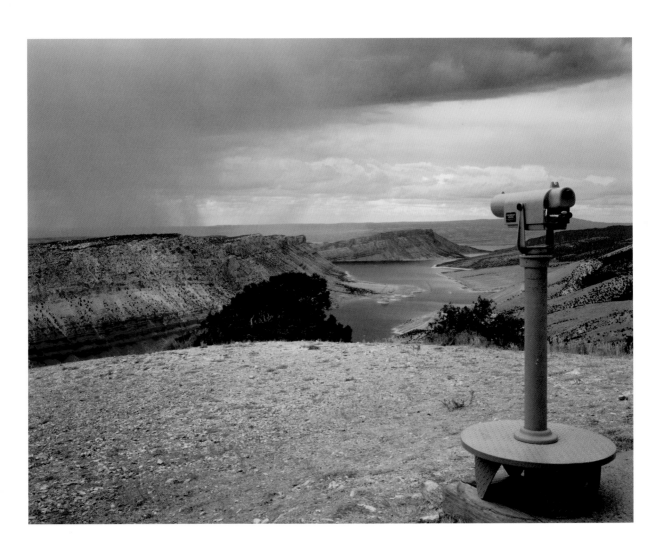

73 **KAREN HALVERSON**
Flaming Gorge Reservoir, Utah/Wyoming, 1994

Plate List

All photographs are from the collection of the J. Paul Getty Museum, Los Angeles.

1
SIR JOHN FREDERICK WILLIAM HERSCHEL
English, 1792–1871
Valley of the Saltina near Brieg at Entrance of the Simplon, 1821
Graphite drawing made with the aid of a camera lucida
19.7 × 29.7 cm (7¾ × 11¹¹⁄₁₆ in.)
Gift of the Graham and Susan Nash Collection
91.GG.98.51

2
UNKNOWN FRENCH PHOTOGRAPHER
Study of Rocks, ca. 1845
Daguerreotype
10.4 × 14.7 cm (4⅛ × 5¹³⁄₁₆ in.)
84.XT.183

3
SAMUEL A. BEMIS
American, 1789–1881
View within Crawford Notch, New Hampshire, ca. 1840
Daguerreotype
15.2 × 20.3 cm (6 × 8 in.)
84.XT.818.14

4
DAVID OCTAVIUS HILL
Scottish, 1802–1870
ROBERT ADAMSON
Scottish, 1821–1848
Colinton Wood, 1843–47
Salted paper print from a calotype negative
19.1 × 15.2 cm (7½ × 6 in.)
84.XM.966.9

5
ANDRÉ GIROUX
French, 1801–1879
The Ponds at Optevoz, Rhône, ca. 1855
Salted paper print from a paper negative
26.7 × 33.5 cm (10½ × 13³⁄₁₆ in.)
84.XP.362.3

6
CAMILLE SILVY
French, 1834–1910
River Scene, France, negative, 1858; print, 1860s
Albumen silver print
25.7 × 35.6 cm (10⅛ × 14 in.)
90.XM.63

7
GUSTAVE LE GRAY
French, 1820–1884
Troops along the Horizon, 1857
From the album *Souvenirs du Camp de Chalons: au Commandant Verly (Military Scenes of Napoleon III's Camp at Chalons)*
Albumen silver print
27 × 34.9 cm (10⅝ × 13¾ in.)
84.XO.377.7

8
GUSTAVE LE GRAY
French, 1820–1884
Futaie (Forest Scene), 1849–52
Albumen silver print from a waxed paper negative
29.7 × 37.6 cm (11¹¹⁄₁₆ × 14¹³⁄₁₆ in.)
84.XM.637.11

9
CHARLES MARVILLE
French, 1816–1879
Fontainebleau, 1854
Salted paper print
15.9 × 21.3 cm (6¼ × 8⅜ in.)
84.XP.259.5

10
ROGER FENTON
English, 1819–1869
View from Ogwen Falls into Nant Ffrancon, 1857
Albumen silver print
42.4 × 36.5 cm (16¹¹⁄₁₆ × 14⅜ in.)
85.XM.169.22

11
ÉDOUARD BALDUS
French, born Germany, 1813–1889
Entrance to the Donzère Pass, ca. 1861
Albumen silver print
33.5 × 42.4 cm (13³⁄₁₆ × 16¹¹⁄₁₆ in.)
84.XO.734.1.20

12
JOHN BEASLY GREENE
American, born France, 1832–1856
Thèbes, Village de Ghezireh, 1853–54
Salted paper print from a waxed paper negative
23.2 × 30.5 cm (9⅛ × 12 in.)
84.XM.361.15

13
FRANCIS FRITH
English, 1822–1898
The Pyramids of Dahshoor, from the East, 1857
Albumen silver print
37.6 × 48.4 cm (14¹³⁄₁₆ × 19¹⁄₁₆ in.)
84.XM.633.5

14

PLATT D. BABBITT
American, 1823–1879
Scene at Niagara Falls, ca. 1855
Daguerreotype
14.8 × 18.1 cm (5¹³⁄₁₆ × 7⅛ in.)
84.XT.866

15

FREDERICK LANGENHEIM
American, born Germany,
1809–1879
WILLIAM LANGENHEIM
American, born Germany,
1807–1874
*Niagara Falls, Summer View,
Suspension Bridge, and
Falls in the Distance,* ca. 1856
Glass stereograph
8.3 × 17.1 cm (3¼ × 6¾ in.)
2000.10.218

16

WILLIAM HENRY JACKSON
American, 1843–1942
*Cameron's Cone from "Tunnel 4,"
Colorado Midland Railway,* 1879
Albumen silver print
53.3 × 44 cm (21 × 17⁵⁄₁₆ in.)
85.XM.5.36

17

WILLIAM HENRY JACKSON
American, 1843–1942
Old Faithful, 1870
Albumen silver print
51.4 × 42.4 cm (20¼ × 16¹¹⁄₁₆ in.)
85.XM.5.38

18

TIMOTHY H. O'SULLIVAN
American, ca. 1840–1882
*Desert Sand Hills near
Sink of Carson, Nevada,* 1867
Albumen silver print
22.2 × 29.2 cm (8¾ × 11½ in.)
84.XM.484.42

19

TIMOTHY H. O'SULLIVAN
American, ca. 1840–1882
*Ancient Ruins in the Cañon de
Chelle, New Mexico, in a Niche
Fifty Feet above Present Cañon
Bed,* 1873
Albumen silver print
27.6 × 19.2 cm (10⅞ × 7⁹⁄₁₆ in.)
Mount: 50.8 × 40.6 cm
(20 × 16 in.)
84.XM.484.4

20

EDWARD S. CURTIS
American, 1868–1952
Canyon de Chelly, 1904
Gold-toned platinum print
24.8 × 32.4 cm (9¾ × 12¾ in.)
84.XM.638.55

21

HENRY P. BOSSE
American, born Germany,
1844–1903
*Wingdams below Ninninger,
Minnesota,* 1891
Cyanotype print
25.5 × 33.3 cm (10¹⁄₁₆ × 13⅛ in.)
Gift of Charles Wehrenberg and
Sally Larsen
2002.43.3

22

CARLETON WATKINS
American, 1829–1916
Solar Eclipse, January 1, 1889
Albumen silver print
16.5 × 21.6 cm (6½ × 8½ in.)
88.XM.92.83

23

CARLETON WATKINS
American, 1829–1916
*Agassiz Rock and the Yosemite
Falls, from Union Point,* ca. 1878
Albumen silver print
54.4 × 39.2 cm (21⁷⁄₁₆ × 15⁷⁄₁₆ in.)
2004.70

24

EADWEARD J. MUYBRIDGE
American, born England,
1830–1904
*Valley of the Yosemite,
from Rocky Ford,* 1872
Albumen silver print
42.9 × 54.5 cm (16⅞ × 21⁷⁄₁₆ in.)
85.XP.14.9

25

LAURA GILPIN
American, 1891–1979
A Devonshire Pattern, 1922
Platinum print
9.4 × 11.7 cm (3¹¹⁄₁₆ × 4⅝ in.)
84.XM.206.3

26

PETER HENRY EMERSON
British, born Cuba, 1856–1936
The Haunt of the Pike, 1886
From the book *Life and Landscape
on the Norfolk Broads*
Platinum print
20.5 × 28.9 cm (8¹⁄₁₆ × 11⅜ in.)
84.XP.259.23

27

ANNE W. BRIGMAN
American, 1869–1950
Figure in a Landscape, 1923
Gelatin silver print
18.4 × 23.5 cm (7¼ × 9¼ in.)
95.XM.73

28

IMOGEN CUNNINGHAM
American, 1883–1976
Evening on the Duwamish River,
ca. 1911
Platinum print
14.8 × 24.1 cm (5¹³⁄₁₆ × 9½ in.)
88.XM.44.1

29

WILLIAM EDWARD DASSONVILLE
American, 1879–1957
Untitled (Trees near Sacramento),
ca. 1900
Sepia-toned gum bichromate print
19.1 × 24.1 cm (7½ × 9½ in.)
84.XP.725.28

30

EDWARD STEICHEN
American, 1879–1973
Pastoral, Moonlight, negative,
1904; print, 1906
Toned photogravure print
16.5 × 20.5 cm (6½ × 8⅛ in.)
86.XM.625.5

31

ANDRÉ KERTÉSZ
American, born Hungary,
1894–1985
Camera in Landscape, 1917–25
Toned gelatin silver print
4.1 × 5.7 cm (1⅝ × 2¼ in.)
86.XM.706.20

32

LEE MILLER
American, 1907–1977
Portrait of Space, 1937
Gelatin silver print
37 × 26.2 cm (14⁹⁄₁₆ × 10⁵⁄₁₆ in.)
84.XP.926.7

33

ALEXANDER RODCHENKO
Russian, 1891–1956
*Wald von Puschkino, Kiefern
(Forest at Pushkino, Pines)*,
negative, 1929; print, 1979
Toned gelatin silver print
37.8 × 28.6 cm (14⅞ × 11¼ in.)
Gift of Michael Wilson
84.XM.978.6

34

MAN RAY
American, 1890–1976
Untitled (Tree Trunk), 1928
Gelatin silver print
29.7 × 23.2 cm (11¹¹⁄₁₆ × 9⅛ in.)
84.XM.1000.40

35

ALBERT RENGER-PATZSCH
German, 1897–1966
Industrial Landscape near Essen,
1930
Ferrotyped gelatin silver print
22.5 × 16.7 cm (8⅞ × 6⁹⁄₁₆ in.)
84.XM.173.76

36

AUGUST SANDER
German, 1876–1964
Untitled (Quarry Pit), ca. 1925–35
Gelatin silver print
16.7 × 25.2 cm (6⁹⁄₁₆ × 9¹⁵⁄₁₆ in.)
84.XM.152.124

37

EUGÈNE ATGET
French, 1857–1927
Blé (Wheat), 1900
Toned albumen silver print
21.3 × 17 cm (8⅜ × 6¹¹⁄₁₆ in.)
84.XM.794

38

ALFRED STIEGLITZ
American, 1864–1946
Grasses, Lake George, 1933
Gelatin silver print
18.7 × 23.8 cm (7⅜ × 9⅜ in.)
93.XM.25.63

39

EUGÈNE ATGET
French, 1857–1927
Saint-Cloud, negative, 1926;
printed later by Berenice Abbott
(American, 1898–1991)
Albumen silver print
17.5 × 22.3 cm (6⅞ × 8¾ in.)
2002.37.14

40

EDWARD WESTON
American, 1886–1958
Sand Dunes, Oceano, California,
1934
Gelatin silver print
23.7 × 19.1 cm (9⁵⁄₁₆ × 7½ in.)
85.XM.215

41

ANSEL ADAMS
American, 1902–1984
El Capitan, Yosemite, negative,
1938; print, 1950
Gelatin silver print
24 × 17.9 cm (9⁷⁄₁₆ × 7¹⁄₁₆ in.)
85.XM.256.8

42

EDWARD WESTON
American, 1886–1958
Point Lobos, November 1938
Gelatin silver print
19.4 × 24.4 cm (7⅝ × 9⅝ in.)
89.XM.70.2

43

EDWARD WESTON
American, 1886–1958
Kelp on Tide Pool, Point Lobos,
1939
Gelatin silver print
19.2 × 24.4 cm (7⁹⁄₁₆ × 9⅝ in.)
84.XM.860.8

44

ANSEL ADAMS
American, 1902–1984
Sugar Pine Cones, negative,
1925–30; print, 1931–32
Gelatin silver print
11.6 × 16.2 cm (4⁹⁄₁₆ × 6⅜ in.)
85.XM.256.5

45

ANSEL ADAMS
American, 1902–1984
*Mt. Williamson from Manzanar,
California*, 1944
Gelatin silver print
19.1 × 23.8 cm (7½ × 9⅜ in.)
84.XP.208.160

46

PAUL STRAND
American, 1890–1976
Side Porch, 1946
Gelatin silver print
24.4 × 19.4 cm (9⅝ × 7⅝ in.)
84.XM.913.1

47

MANUEL ÁLVAREZ BRAVO
Mexican, 1902–2002
Invented Landscape, negative,
1972; print, 1974
Gelatin silver print
28.9 × 36.2 cm (11⅜ × 14¼ in.)
84.XM.676.15

48

MANUEL ÁLVAREZ BRAVO
Mexican, 1902–2002
Las Bocas (The Mouths), 1963
Gelatin silver print
19 × 21.5 cm (7½ × 8⁷⁄₁₆ in.)
Gift of Daniel Greenberg and
Susan Steinhauser
2008.88.12

49

HARRY CALLAHAN
American, 1912–1999
Detroit, 1941
Gelatin silver print
8.1 × 11.4 cm (3³⁄₁₆ × 4½ in.)
88.XM.65.10

50

FREDERICK SOMMER
American, born Italy, 1905–1999
Colorado River Landscape, 1940
Gelatin silver print
19.1 × 24.1 cm (7½ × 9½ in.)
94.XM.37.72

51

WILLIAM A. GARNETT
American, 1916–2006
*Sandbars, Cape Cod,
Massachusetts*, 1966
Cibachrome print
39 × 51.7 cm (15⅜ × 20⅜ in.)
2003.77

52

FREDERICK SOMMER
American, born Italy, 1905–1999
Glass, 1943
Gelatin silver print
19.1 × 24.1 cm (7½ × 9½ in.)
94.XM.37.84

53

HARRY CALLAHAN
American, 1912–1999
Chicago, ca. 1948
Gelatin silver print
9.2 × 11.9 cm (3⅝ × 4¹¹⁄₁₆ in.)
88.XM.65.12

54

WILLIAM A. GARNETT
American, 1916–2006
*Rabbit and Cattle Tracks, Carrizo
Plain, California*, 1955
Gelatin silver print
34.1 × 26.4 cm (13⁷⁄₁₆ × 10⅜ in.)
2000.32.14

55

WYNN BULLOCK
American, 1902–1975
Tide Pool, 1957
Gelatin silver print
19.1 × 24.1 cm (7½ × 9½ in.)
2010.73.6

56

JOSEF SUDEK
Czech, 1896–1976
A Walk on Kampa Island, 1956
Gelatin silver print
22 × 28.3 cm (8¹¹⁄₁₆ × 11⅛ in.)
2000.29.3

57

BRETT WESTON
American, 1911–1993
White Sands, New Mexico, 1947
Gelatin silver print
19.4 × 24.3 cm (7⅝ × 9⁹⁄₁₆ in.)
88.XM.69.1

58

AARON SISKIND
American, 1903–1991
Martha's Vineyard 111B, 1954
Gelatin silver print
27.5 × 34.3 cm (10¹³⁄₁₆ × 13½ in.)
84.XM.1012.109

59

AARON SISKIND
American, 1903–1991
Volcano 129, 1980
Gelatin silver print
35.8 × 35.6 cm (14⅛ × 14 in.)
Gift of Dan and Jeanne Fauci
family collection
2005.90.2

60

MINOR WHITE
American, 1908–1976
*Eroded Sandstone, Point Lobos
State Park, California*, 1950
Gelatin silver print
20.2 × 26.5 cm (7¹⁵⁄₁₆ × 10⁷⁄₁₆ in.)
84.XM.861.1

61

DOROTHEA LANGE
American, 1895–1965
*The Road West / Highway to the
West, U.S. 54 in Southern New
Mexico*, negative, 1938; print, 1965
Gelatin silver print
18.7 × 23.8 cm (7⅜ × 9⅜ in.)
2001.36.1

62

ELIOT PORTER
American, 1901–1990
*Aspens, Elk Mountain Road,
New Mexico*, 1972
Dye transfer print
26.2 × 20.6 cm (10⁵⁄₁₆ × 8⅛ in.)
Gift of Daniel Greenberg and
Susan Steinhauser
2005.93.54

63

ROBERT ADAMS
American, b. 1937
*Quarried Mesa Top, Pueblo
County, Colorado*, 1978
Gelatin silver print
38 × 47.5 cm (14¹⁵⁄₁₆ × 18¹¹⁄₁₆ in.)
2003.117.32

64

ROBERT ADAMS
American, b. 1937
*Burning Oil Sludge North of
Denver, Colorado*, 1973
Gelatin silver print
15.2 × 19.4 cm (6 × 7⅝ in.)
2003.117.1

65

JERRY UELSMANN
American, b. 1934
Navigation without Numbers, 1971
Gelatin silver print
20.7 × 20.3 cm (8⅛ × 8 in.)
Gift of Anne B. and Marvin H.
Cohen
2006.41.1

66

JAMES IRWIN FOR NASA
American, 1930–1991
Astronaut, Lunar Surface,
August 1, 1971
Gelatin silver print
35.7 × 35.1 cm (14⅟₁₆ × 13¹³⁄₁₆ in.)
84.XP.775.12

67

TOSHIO SHIBATA
Japanese, b. 1949
*Shimogo Town, Fukushima
Prefecture,* 1990
Gelatin silver print
44.8 × 55.8 cm (17⅝ × 21¹⁵⁄₁₆ in.)
Purchased with funds provided
by the Photographs Council of the
J. Paul Getty Museum
2006.19.6

68

JOHN PFAHL
American, b. 1939
Blue X, Pembroke, New York, 1975
From the portfolio *Altered
Landscapes: The Photographs of
John Pfahl*
Dye transfer print
19.5 × 25.7 cm (7¹¹⁄₁₆ × 10⅛ in.)
2010.19.10

69

JOEL STERNFELD
American, b. 1944
*Potato Harvest, Aroostook County,
Maine,* October 1982, negative,
October 1982; print, November
1986
From the book *American Prospects*
Chromogenic dye coupler print
34.3 × 43.2 cm (13½ × 17 in.)
Gift of Nancy and Bruce Berman
98.XM.225.3

70

VIRGINIA BEAHAN
American, b. 1946
LAURA MCPHEE
American, b. 1958
Mount Rainier, Washington, 2000
Chromogenic dye coupler print
75.9 × 94.3 cm (29⅞ × 37⅛ in.)
Gift of Nancy Goliger
and Bruce Berman
2008.80.10

71

VIRGINIA BEAHAN
American, b. 1946
LAURA MCPHEE
American, b. 1958
*Apple Orchard, Manzanar
Japanese American Relocation
Camp, Owens Valley, California,*
1995
Chromogenic print
75.3 × 95.3 cm (29⅝ × 37½ in.)
Gift of Nancy and Bruce Berman
2003.517.5

72

JOHN DIVOLA
American, b. 1949
N34°10.744'W116°07.973',
negative, 1995–98; print, 1998
From the series Isolated Houses
Lightjet print
75.6 × 75.6 cm (29¾ × 29¾ in.)
Gift of Nancy and Bruce Berman
99.XM.88.11

73

KAREN HALVERSON
American, b. 1941
*Flaming Gorge Reservoir,
Utah/Wyoming,* 1994
Chromogenic dye coupler print
71.1 × 91.4 cm (28 × 36 in.)
Gift of Nancy and Bruce Berman
99.XM.73.3

This publication is issued on the occasion of the exhibition
In Focus: Depth of Field, on view at the J. Paul Getty Museum at
the Getty Center, Los Angeles, from May 22 to October 7, 2012.

© 2012 J. Paul Getty Trust

Published by the J. Paul Getty Museum, Los Angeles
Getty Publications
1200 Getty Center Drive, Suite 500
Los Angeles, California 90049-1682
www.getty.edu/publications

Beatrice Hohenegger, *Editor*
Jeffrey Cohen, *Designer*
Stacy Miyagawa, *Production Coordinator*

Printed in China

Library of Congress Cataloging-in-Publication Data
Hellman, Karen.
Landscape in photographs / Karen Hellman, Brett Abbott.
 p. cm.
 ISBN 978-1-60606-103-9 (hardcover)
1. Nature—Pictorial works. 2. Landscapes—Pictorial works.
I. Abbott, Brett, 1978- II.Title.
 TR721.H45 2012
 779'.36—dc23
 2011036862

FRONT JACKET: William A. Garnett, *Sandbars, Cape Cod,
Massachusetts* (detail, plate 51), 1966
BACK JACKET: Eadweard J. Muybridge, *Valley of the Yosemite,
from Rocky Ford* (plate 24), 1872
PAGE 1: William Henry Jackson, *Cameron's Cone from "Tunnel
4," Colorado Midland Railway* (plate 16), 1879
PAGE 2: Toshio Shibata, *Shimogo Town, Fukushima Prefecture*
(detail, plate 67), 1990
PAGE 3: Peter Henry Emerson, *The Haunt of the Pike* (detail,
plate 26), 1886
PAGES 4-5: Karen Halverson, *Flaming Gorge Reservoir, Utah /
Wyoming* (detail, plate 73), 1994